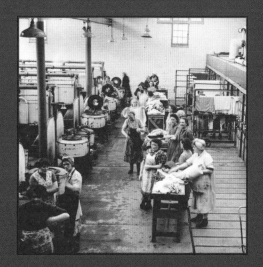

GLASGOW 1955: Through the Lens

Glasgow|museums

First published in 2008 by Culture and Sport Glasgow (Museums)
All text and images © Culture and Sport Glasgow (Museums)
Reprinted 2008, reprinted 2010

ISBN 978 0902752 89 4

Text by: Fiona Hayes and Peter Douglas, with Martin Bellamy
Edited by: George Inglis
Designed by: Fiona MacDonald

Reproduction and printing by Allander Print Limited; printed in Scotland.

Acknowledgements
We gratefully acknowledge the help of the following in collating the material for this book: Alf Daniel, George
Parsonage, Govan Reminiscence Group, Queen's Park Camera Club, Tommy Stewart, Sidney Taylor-Duncan, Isobel
McDonald and The Glasgow Story (www.theglasgowstory.com).

Images from the book, along with other images from the 1955 Photographic Survey of Glasgow, are available from
Glasgow Museums Photo Library, phone (+44) (0)141 287 2595; web www.glasgowmuseums.com/photolibrary.

CONTENTS:

FOREWORD

Mark O'Neill

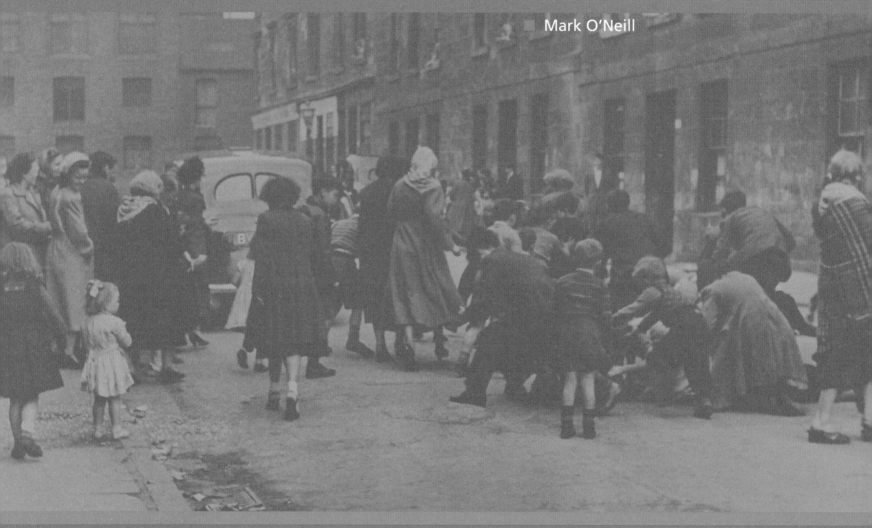

Photography is one of the great Victorian inventions. It is the most democratic art form – anyone who wishes, without the years of training required to learn to draw, paint or sculpt, can make representations of the world that are astonishingly accurate – though we are less astonished now that we take images so much for granted.

Many of the ways of life invented in Victorian Glasgow continued intact until the late 1950s. When the Glasgow camera clubs decided to record life in their city, they may have had an inkling of major change being about to happen, but they could hardly have imagined its true scale. What they created was a record of a city that in many ways has more in common with its Victorian forebear than with that of our time, a fascinating study of differences and similarities with 21st-century Glasgow.

As well as being the most accessible art form, photography is also the most difficult in which to achieve a personal vision. Most photographs could have been taken by almost anyone. The quality of the 1955 Survey photographs reveals a group of people who had a sharp eye, who were able to see beyond standard perspectives to reveal something important about their city, on the verge, as it was, of a vast transformation.

I would like to take this opportunity to thank the camera clubs and their members for their invaluable contribution to documenting the history of Glasgow.

Mark O'Neill
Head of Arts and Museums
Culture and Sport Glasgow

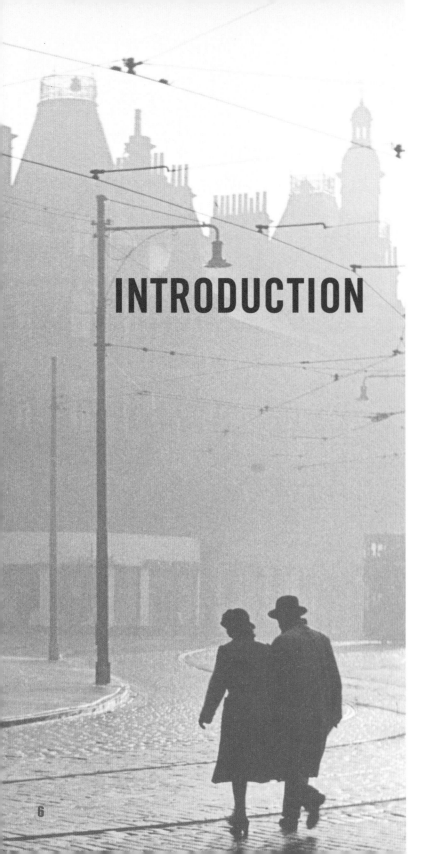

INTRODUCTION

The summer of 1955 in Glasgow was hot, very hot. It was so hot that there are reports of melting tarmac, and children in Kelvingrove Park escaped the heat by playing in the water of the Stewart Fountain. This image of Glasgow in 1955 has been recorded not just in official statistics or in people's memories, but in a remarkable photographic survey carried out by the city's camera clubs and which is now part of Glasgow Museums' collection.

The idea for a citywide photographic survey began as a discussion after one of Partick Camera Club's weekly meetings [1]. Under the leadership of Adam Stevens, Partick Camera Club's energetic president, it soon blossomed into a full-scale project involving ten of Glasgow's camera clubs with 86 amateur photographers, and resulted in 600 photographic prints that record all aspects of Glasgow life.

The aim of the survey is captured in the letter Adam Stevens sent to Partick Camera Club members in April 1955 to encourage participation:

Dear Member
As you probably know, your Club is now engaged with others on the Photographic Survey of the City of Glasgow. This Survey, which will be exhibited by the Art Galleries some time in the Autumn, must be completed by the beginning of September and we cannot hope to do that without your help. If you are wondering about what you can do, may we remind you that as we are trying to cover every phase and aspect of this City, your opportunities are almost limitless. The streets where you live, the streets where you work, your cultural activities, your leisure, your sports and your recreations – provided they take place within the city boundaries – all these are subjects for your camera and they should have a place in this survey.[2]

The photographers gave up their evenings and weekends to work on this project. Sometimes their photographic work had an unintended effect on their families, as the granddaughter of one of the survey photographers recalled during the exhibition to celebrate the 50th anniversary of the survey:

My lovely, long suffering Auntie (who lived with my granda) had a few not so good memories – such as not being able to have a bath because the bathroom was used as a darkroom and the bath was always full of developing fluid![3]

Photographic surveys were not new. As early as the 1860s a survey was commissioned by the Glasgow City Improvement Trust to photograph and record inner city slums. But what is interesting about the 1955 survey is that it is entirely the work of dedicated amateurs. By the 1950s photography had become a very popular hobby. The development of relatively cheap, good quality cameras meant that people from all social backgrounds could take it up and produce work of a high standard.

Camera clubs enabled amateur photographers to pursue their interest and develop their skills through discussion, practice and competition. The diverse membership of the camera clubs meant that many areas of the city were depicted through the photographers' workplaces, leisure pursuits and personal interests, which probably would not have been recorded in a professional survey. Although the areas and themes were suggested by the survey organizing committee, the photographers interpreted them loosely and with great affection for their subject.

In September 1955 the photographs went on display for a month in Kelvingrove Art Gallery and Museum in the exhibition *Glasgow by Camera*. Partick Camera Club then donated the photographs to the City of Glasgow. As the photographers had intended, the survey has become a record of Glasgow life in 1955. Fifty years later, new prints of some of the photographs went on display in the People's Palace and Winter Gardens to mark the 50th anniversary of the survey.

The survey provides a fascinating glimpse into everyday life in Glasgow in 1955. Glasgow was a busy, noisy, polluted industrial city of over a million people. The River Clyde was still a major waterway, its banks lined with world famous shipyards and its docks busy loading and unloading goods from all over the world.

Most people lived near their place of work and were employed in local factories and heavy industries. Overcrowding and poor housing were ongoing problems and the lack of adequate accommodation was a factor in many a Glaswegian's decision to emigrate to Canada, Australia or South Africa. Home for most people was a one- or two-roomed tenement house with shared toilets, what were known as a 'single end' or 'room and kitchen'. Although World War II had ended nearly ten years previously, rationing continued until 1954 and the effects of post-war austerity were still being felt. Holidays were the annual 'Fair Fortnight' in July when factories and offices closed and the city was deserted. Many Glaswegians went 'doon the watter' as their parents and grandparents might have done, holidaying on the Clyde coast rather than going abroad.

And yet there were major changes on the way. Glasgow Corporation had begun an ambitious plan for the future. It would not only rebuild the bomb-damaged city, but the *Clyde Valley Plan* of 1943 and Glasgow Corporation's own 50-year scheme, led by City Engineer Robert Bruce, aimed to create a new modern city. The plan favoured decentralization, moving people and industry away from the city centre to the outskirts and to new towns such as East Kilbride and Cumbernauld. Overcrowded inner city communities would be moved to new housing developments on the edge of the city in Drumchapel, Castlemilk and Easterhouse. The new homes offered a better standard of living – electricity, houses with indoor toilets and

bathrooms, and perhaps a garden. Missed off the planners' list, though, were local amenities, and many people ended up with a long bus ride back into the city centre for shopping and for leisure activities.

Transport in the city was also to alter with this plan. There were still few cars on the road but improved road transport and a new road system were all part of the *Bruce Plan*. Already by 1955, buses were beginning to replace trams on the road and there were less heavy horses to be seen transporting goods across Glasgow. The motorways of the 1970s and 1980s were still a long way off. Smog and pollution were commonplace, but the Clean Air Act of 1956 began to address this and the health problems it caused. TB (tuberculosis) was still a major public health problem, due to be tackled within a few years by one of the largest – and most successful – public health campaigns in Glasgow's history. 1955 was also the year when the teenager and youth culture was born – 'unleashed', many would say – with the release of Bill Haley's recording 'Rock Around the Clock', and there is a glimpse of this in a few of the photographs.

There were of course changes that only a few people might have been able to predict, such as the virtual disappearance of the city's industrial and manufacturing base within 30 years. For generations, many people's concept of personal and community identity had been bound up with their workplace, and the idea of 'a job for life' needed to be changed as heavy industry collapsed. The post war industrial boom had masked the effects of the use of out of date industrial practices in a world that favoured the cheaper production line methods being developed in the Far East and America. Glasgow was still making Victorian industrial vehicles and equipment using Victorian manufacturing technologies and Victorian management techniques.

In the 1950s, as the British Empire crumbled and the Commonwealth developed, people from the new independent countries such as Pakistan came to Glasgow to work and live. There is no sign in the survey photographs of the multicultural and multifaith city Glasgow would become within 50 years.

The 1955 survey was partly prompted by the changes that were being proposed for developing the city. However, the scale and nature of the change was beyond everyone's expectation. This survey, therefore, captures a city on the cusp. It was still riding high on industrial confidence, and the early high-rise developments shown here promised hope and a brave new world. However, few could have foreseen quite how radically different the city would become in such a short time.

The organizers certainly achieved their ambition of creating photographs that, 'Will be available to future generations of Glasgow citizens, as yet unborn, as a factual and almost visible record of their city in 1955'. Their city is a city which is still recognizable, but there are also elements of it which to today's citizens seem completely alien. Without the camera clubs' vision, we would not have this record of the city at such an important phase in its history.

1. Information from conversation with Sidney Taylor-Duncan, 26 June 2006.

2. Copy of letter courtesy of Sidney Taylor-Duncan, 26 June 2006.

3. Quote left on exhibition comments board, *Glasgow 1955: Through the Lens*, People's Palace and Winter Gardens, January–March 2006.

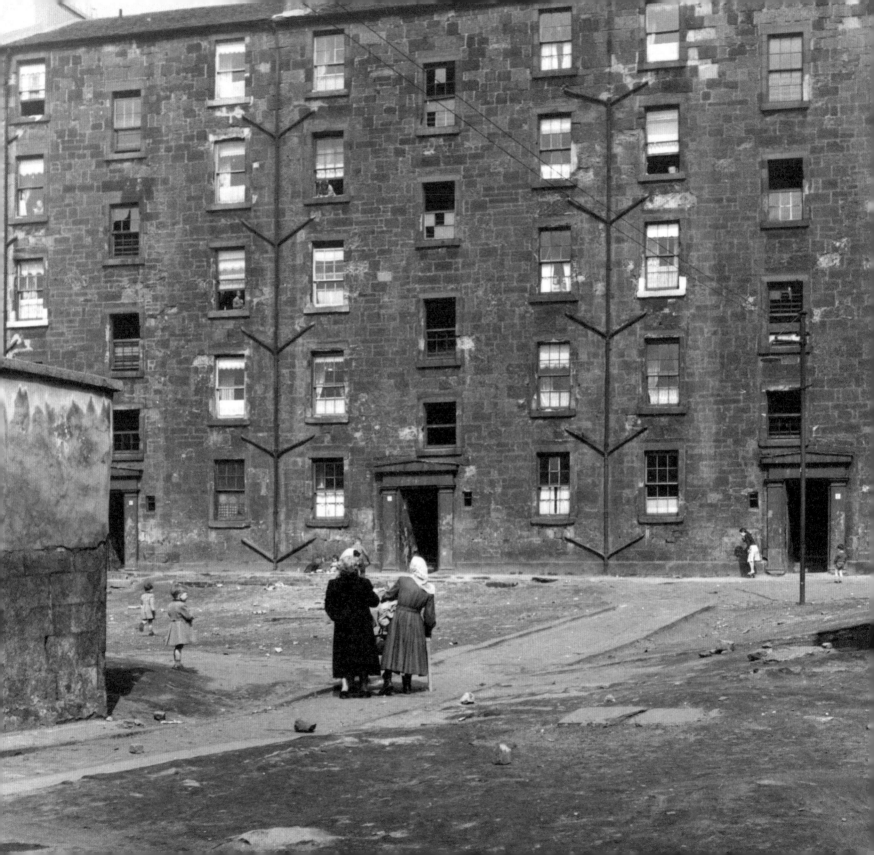

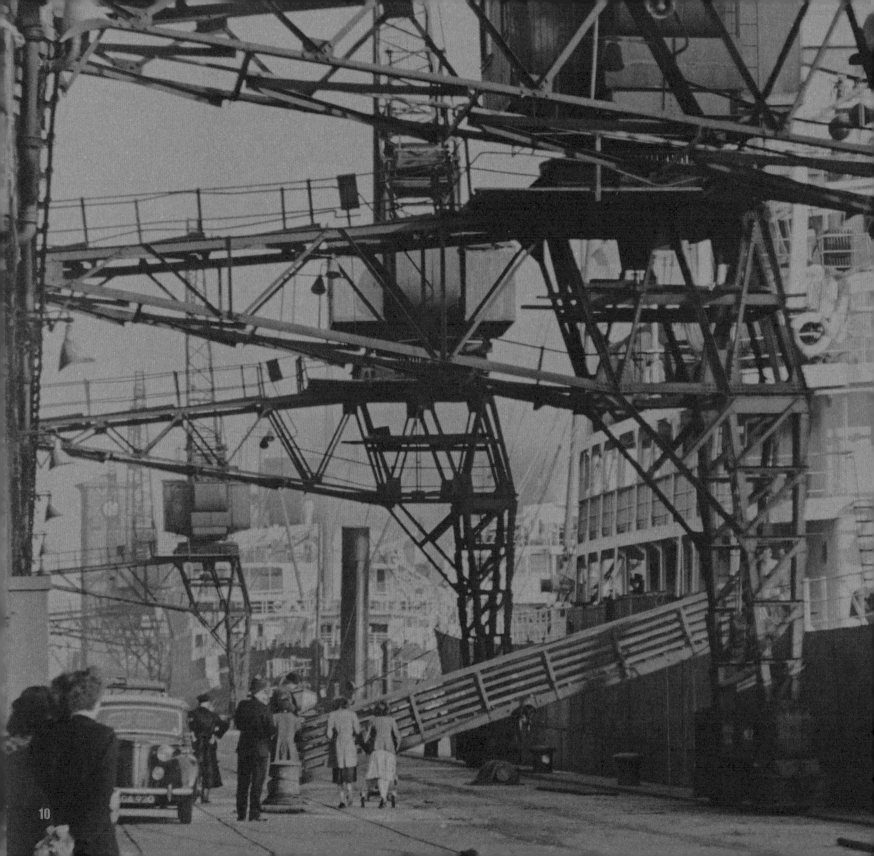

THE
CLYDE

GLASGOW 1955:
THROUGH THE LENS

" ... times spent crossing the River Clyde on the many ferries and seeing ships from all parts of the world berthed at various quaysides, unloading exotic cargoes and seeing sailors from different cultures in our city. The sights and sounds of the shipyards will remain etched in my memory forever. "

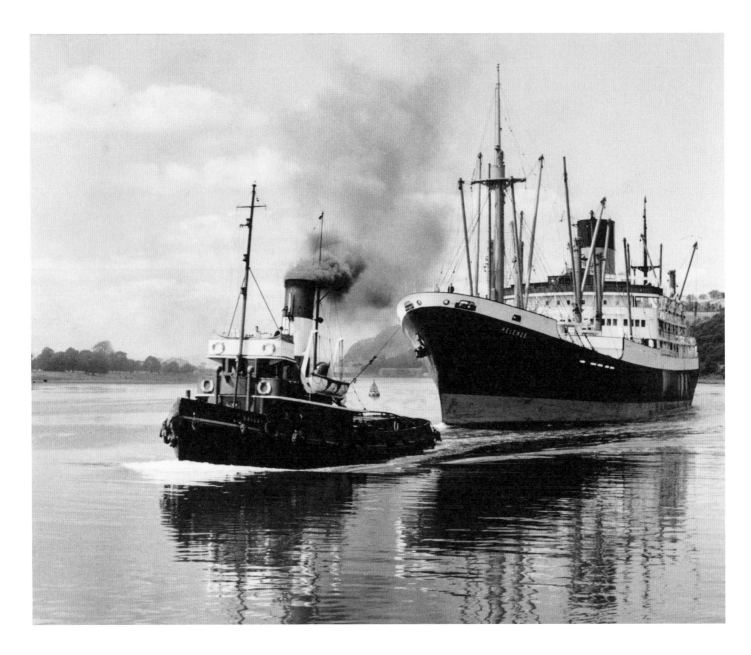

Leading Her Home
James Logan

Partick Camera Club

When this photograph was first shown in 1955 it was captioned, 'An everyday job on the Clyde'. It shows the Steel & Bennie tug *Brigadier* towing the Blue Funnel Line's cargo liner *Helenus* up the Clyde after a voyage from Australia via the Suez Canal.

OG.1955.121.[34]

■ **Sailing up the Clyde**
Photographer and club unknown

It looks like a fine summer's day as the *Queen Mary II* makes its way up the River Clyde after a trip 'doon the watter' – down the Clyde coast – which was still a popular holiday choice in the 1950s. On the left, one of the Anchor Line's vessels waits to be loaded with cargo at Yorkhill Quay. In the background are the familiar landmarks of the Finnieston Crane and the Pumphouse. Straight ahead is the mouth of Queen's Dock.

OG.1955.121.[257]

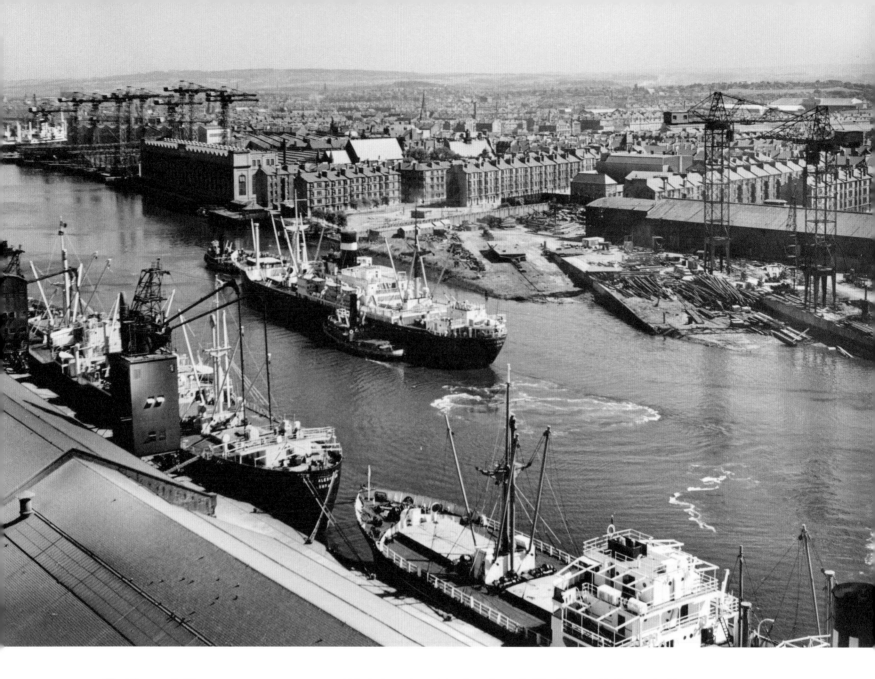

■ **Glasgow's River**
Andrew Gibb
Partick Camera Club

This photograph was taken from the roof of the Meadowside Granary looking east. It clearly shows how busy the River Clyde still was in the 1950s. Ships lie berthed at Meadowside Quay. On the south bank of the river, the Govan shipyards of Fairfield's and Harland & Wolff are clearly identified by their ranks of cranes.

OG.1955.121.[44]

View of Shipyard
S Taylor-Duncan
Partick Camera Club

A ship stands on the stocks at Barclay Curle & Company's shipyard at Clydeholm, Whiteinch. The hammerhead crane in the distance marks Fairfield Shipbuilding & Engineering Company in Govan, with the *Empress of Britain* being fitted out. The ship is the *Nardana*, a general cargo vessel built for the British India Steam Navigation Company and launched in 1956. Barclay Curle & Company ceased shipbuilding in 1967 after 123 years, and Fairfields became part of Upper Clyde Shipbuilders as part of a major restructure of the industry on the Clyde. The Whiteinch ferry is also visible in the photograph.

OG.1955.121.[237.d]

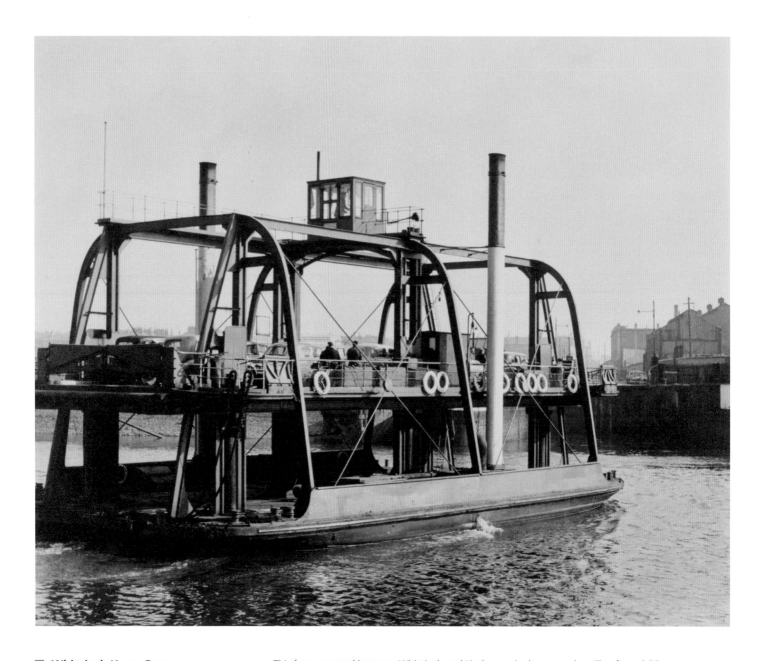

■ **Whiteinch Horse Ferry**
Photographer and club unknown

This ferry operated between Whiteinch and Linthouse six days a week, sailing from 6.30am to 6.30pm Monday to Friday, and from 6.30am to 4pm on Saturday. In 1891 a steam-operated ferry was introduced to take horses, carts and their drivers, as well as foot passengers, across the river. This was known as the Whiteinch Horse Ferry, to distinguish it from the passengers-only ferry. This 'elevating deck' ferry was introduced in 1905. Its platform deck could be raised or lowered to the level of the landing quay, no matter how low or high the tide. When the Clyde Tunnel opened in 1963, the ferry service was withdrawn.

OG.1955.121.[259]

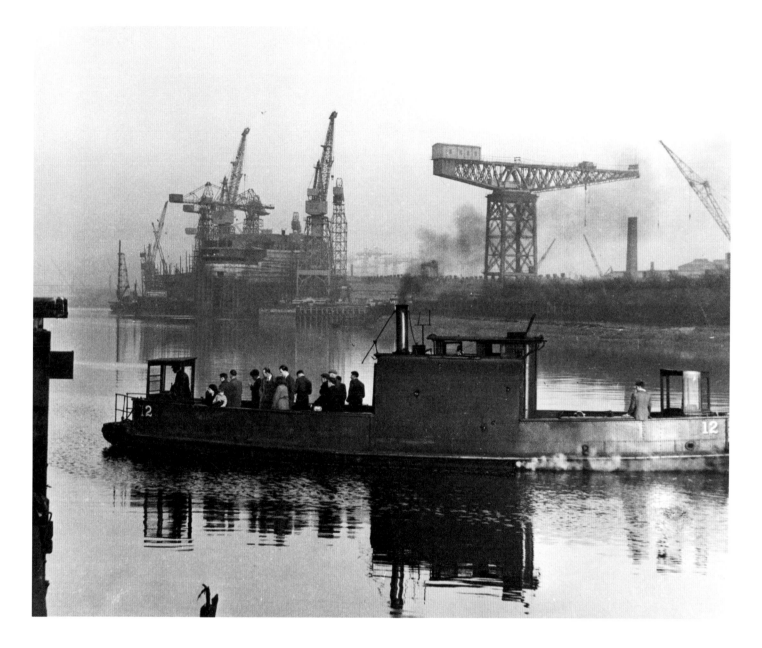

■ **Whiteinch Ferry**
JM Milne
Scottish Ramblers Association

The Whiteinch passenger ferry nears its landing point on the north bank of the Clyde one evening in 1955. The ferry operated seven days a week between Linthouse and Whiteinch, from 5am to 11pm Monday to Friday, 5am to midnight on Saturday, and from 6.30am to 4pm on Sunday. Across the river, the unfinished *Empress of Britain* sits on the stocks at the Fairfield Shipyard. This was the last big liner built at Govan. It was launched by Queen Elizabeth II in June 1955 for the Canadian Pacific line. The ferry stopped operating in 1963 when the Clyde Tunnel opened.

OG.1955.121.[33]

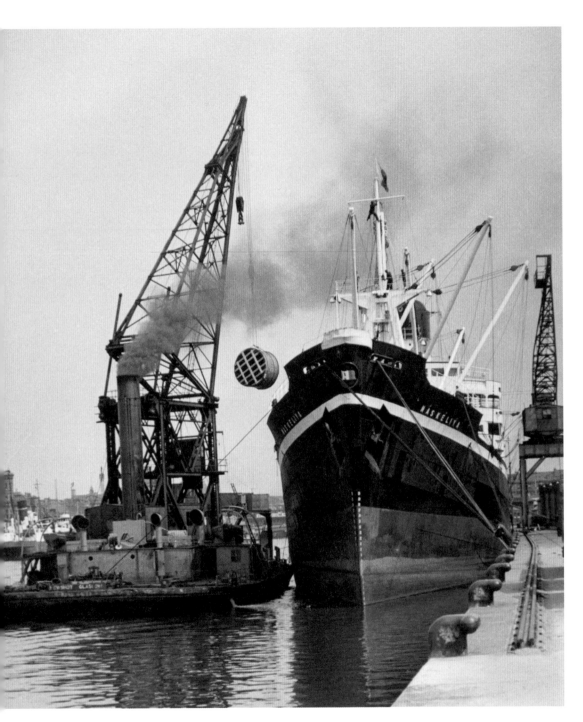

Loading on the Clyde for Africa
D Smith
Dennistoun Camera Club

Another busy day on the Clyde docks as Clyde Navigation Trust's floating crane *Newshot* loads a drum of cabling on to the TSS *Maskeliya* in preparation for her voyage to Africa. Bought in 1946, the Paisley-built *Newshot* was the Trust's only cargo handling craft, and had a lifting capacity of 60 tons (60.96 metric tons). William Hamilton & Company, Port Glasgow, built the cargo ship TSS *Maskeliya* in 1954. She was scrapped in 1972.

OG.1955.121.[31]

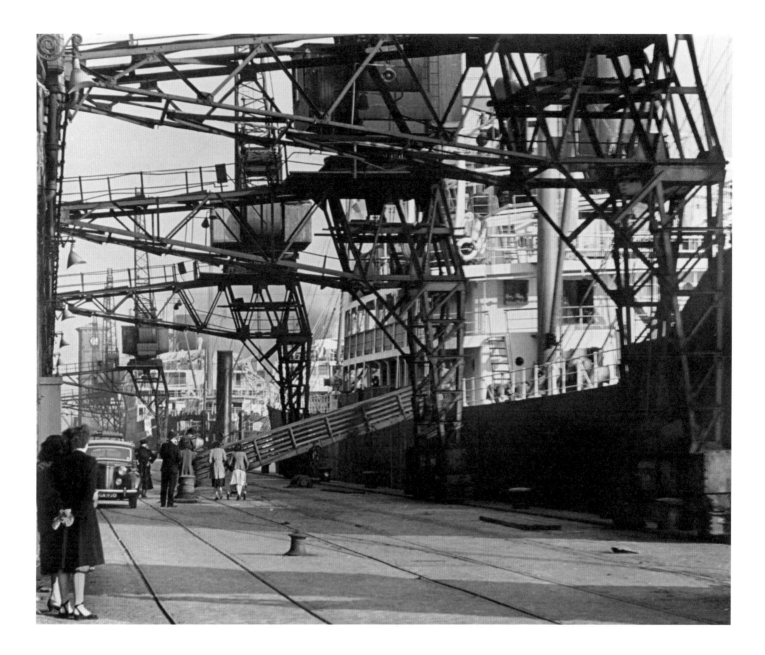

■ **Yorkhill Quay, Berth of the Famous Anchor Liners**
WC Miller
Leica Club of Glasgow

Anchor Line passenger and cargo ships sailed from Yorkhill Quay to New York, and to Bombay – now known as Mumbai. The transatlantic passenger service ended in 1956 and the service to India a decade later. This view looks east along the Clyde towards the city centre – the distinctive Pumphouse can be seen on the left.

OG.1955.121.[40]

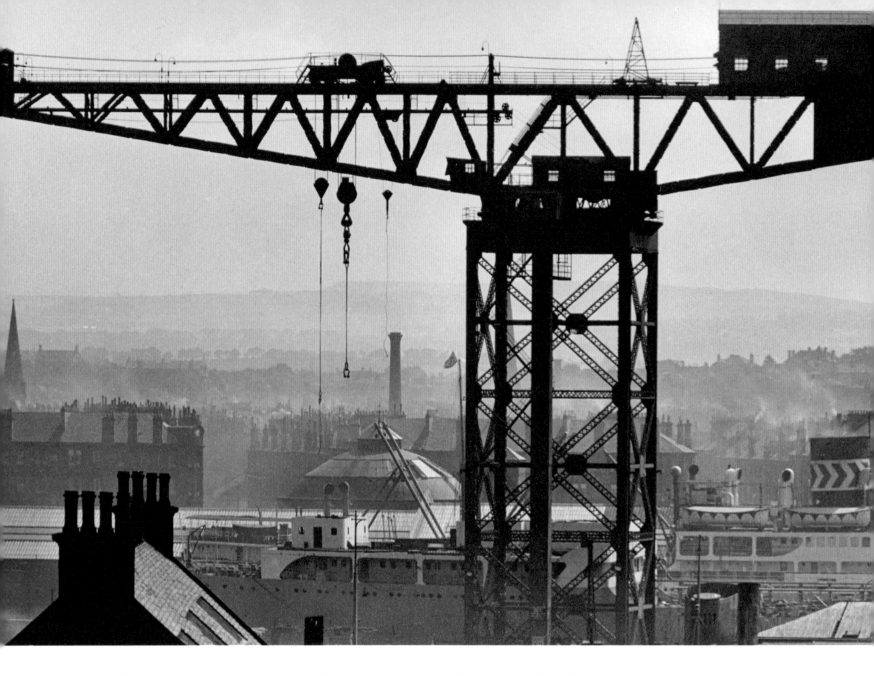

■ **Finnieston Crane**
John McNeish
Leica Club of Glasgow

Glasgow's largest crane was completed in 1932 for the Clyde Navigation Trust. It was used to install boilers and engines into newly built vessels, and to load ships with heavy goods such as locomotives. This giant now stands as a reminder of the city's heavy industry and its busy docks. It dwarfs the domed south rotunda on Mavisbank Quay, Govan, the entrance to Glasgow Harbour Tunnel.

OG.1955.121.[178]

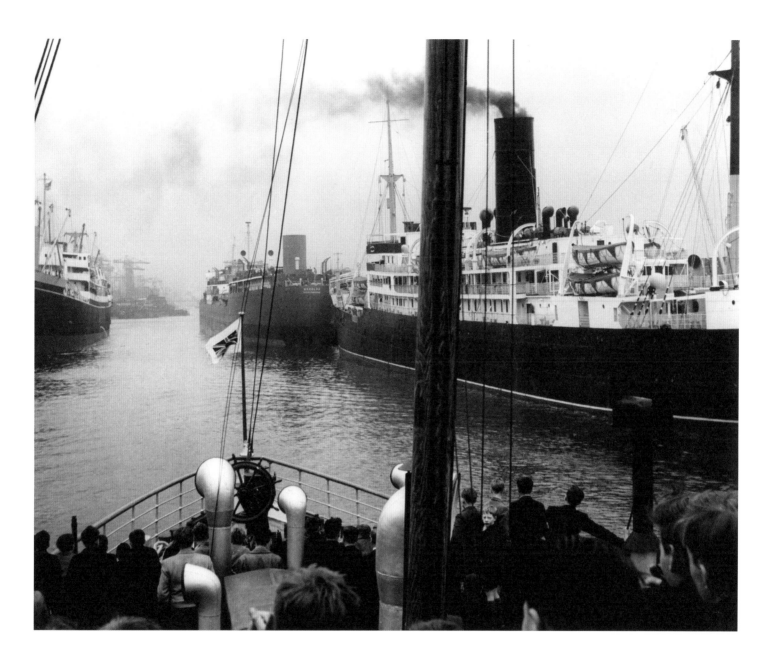

Sailing Down the Clyde
Alf Daniel
Partick Camera Club

In contrast with the Clyde today, this photograph shows how busy the river was in the 1950s and also the size of vessels that made their way along it to the centre of the city. Passenger liners and cargo ships line the banks of the river. In the distance, cranes mark out the shipyards, which even in the 1950s produced many of the world's ships.

OG.1955.121.[199]

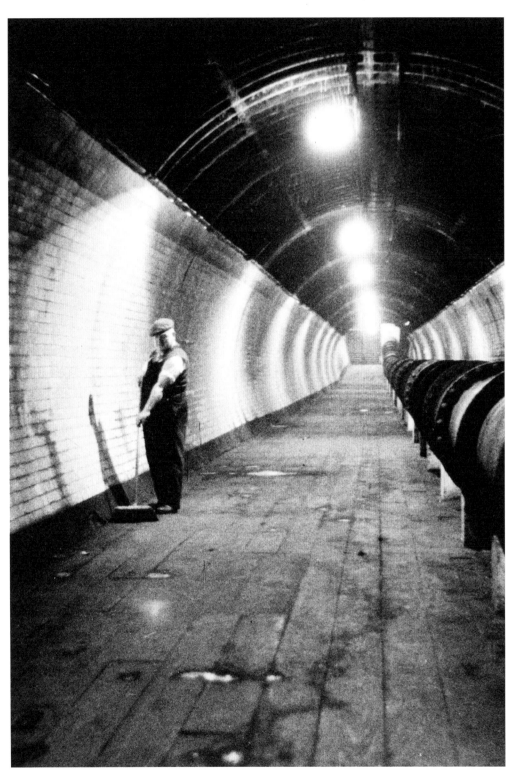

■ **Clyde Tunnel, Plantation**
Michael Martin
Glasgow South Co-operative Club

Long before the present Clyde Tunnel was
constructed, the Clyde Harbour Tunnel ran
beneath the river. Opened in 1895, its three
tunnels, each 16 feet (4.87 metres) in diameter,
ran from Tunnel Street in Finnieston to Mavisbank
Quay in Govan. Two of the tunnels were for
vehicles and one was for pedestrians. Two
rotundas, one on each side of the river, marked
the tunnel entrances. The vehicle tunnels were
closed in 1943, but the pedestrian tunnel
remained open until 1980. Despite the best
efforts of the cleaner in the photograph, a
walk through the tunnel was never particularly
pleasant, being rather damp, smelly and poorly
lit. The large pipe is a water main.

OG.1955.121.[79]

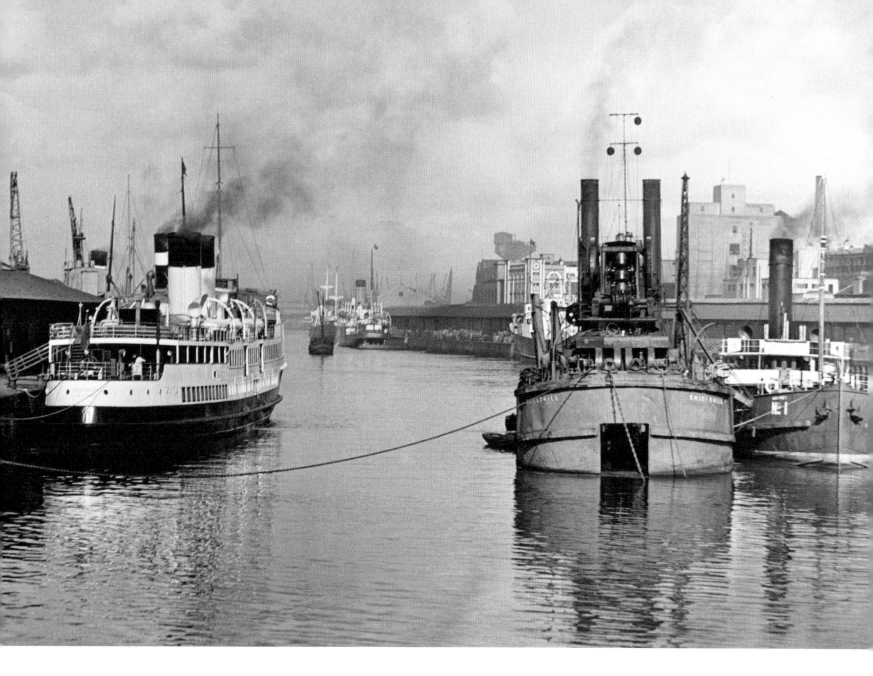

■ **On the Clyde from George V Bridge**
John W Robb
Glasgow South Co-operative Club

Looking west along the Clyde, the pleasure steamer *Queen Mary II* lies berthed at Clyde Place Quay. The Clyde Navigation Trust's dredger *Shieldhall* and *Hopper Barge No.1* are busy keeping the river dredged. In the distance you can see the Finnieston Crane.

OG.1955.121.[52]

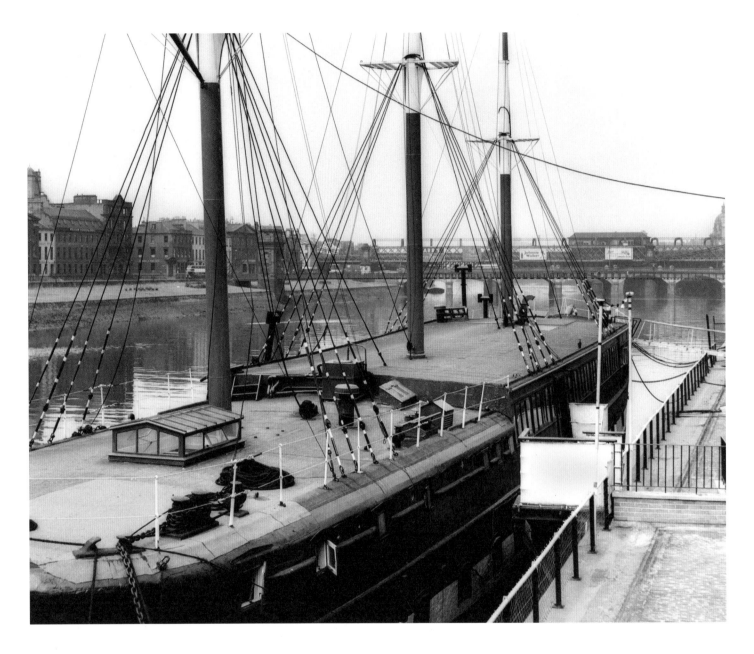

The Carrick – The Only Floating Club in Glasgow
Edward A Russell
Queen's Park Camera Club

For over 40 years the clipper *Carrick* was the Royal Naval Volunteer Reserve Club and a familiar landmark on the Clyde. Here she is moored on the north bank of the river opposite Carlton Place. Built in 1864 as the *City of Adelaide*, she sailed the trade routes to Australia. Today she lies at the Scottish Maritime Museum, Irvine, while funding is sought for her preservation and restoration.

OG.1955.121.[117]

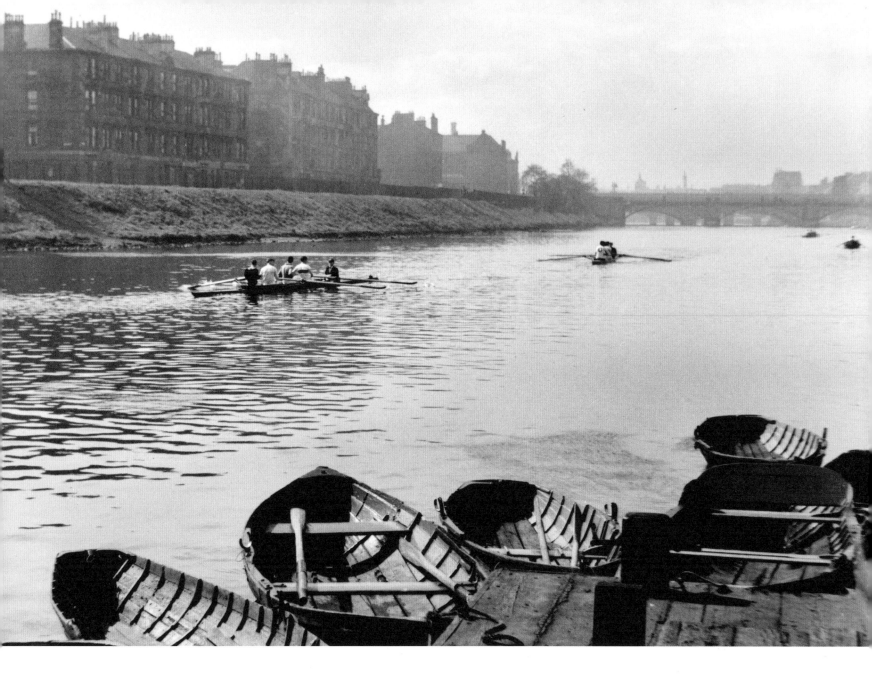

Rowing on the Clyde
John S Logan
Scottish Ramblers Association

This photograph is taken from the Glasgow Humane Society pontoon at Glasgow Green, and looks southwest along the River Clyde. Boats from Glasgow Schools' Rowing Club, possibly Hutchesons' Grammar School or Allan Glen's, are out on the river. The Glasgow Schools shared a club with Clyde Amateur Rowing Club further upstream on the north bank. Rowing on the Clyde has been a popular pastime and spectator sport for the past 200 years, and continues today. The tenements on the south bank were demolished in the 1960s.

OG.1955.121.[170]

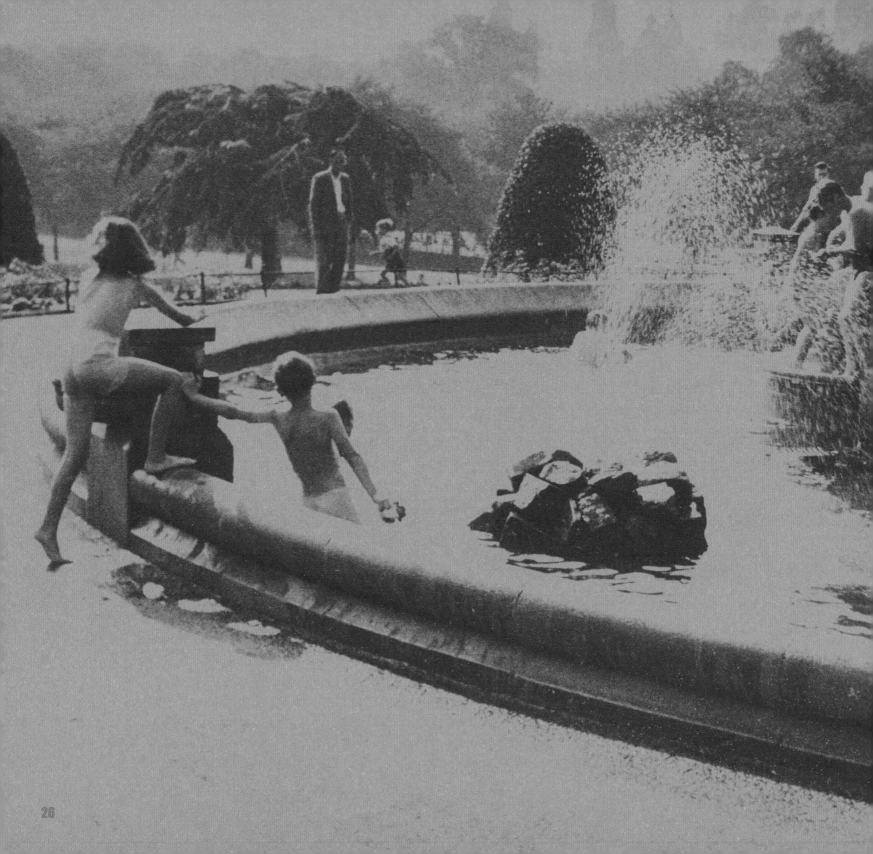

PARKS

" Great memories of coming with "the pals" for picnics complete with wee sister in pram, lemonade bottles full of water, and jam sandwiches. Returning home freckled, happy and waterlogged having refilled the lemonade bottle several times from a standpipe. "

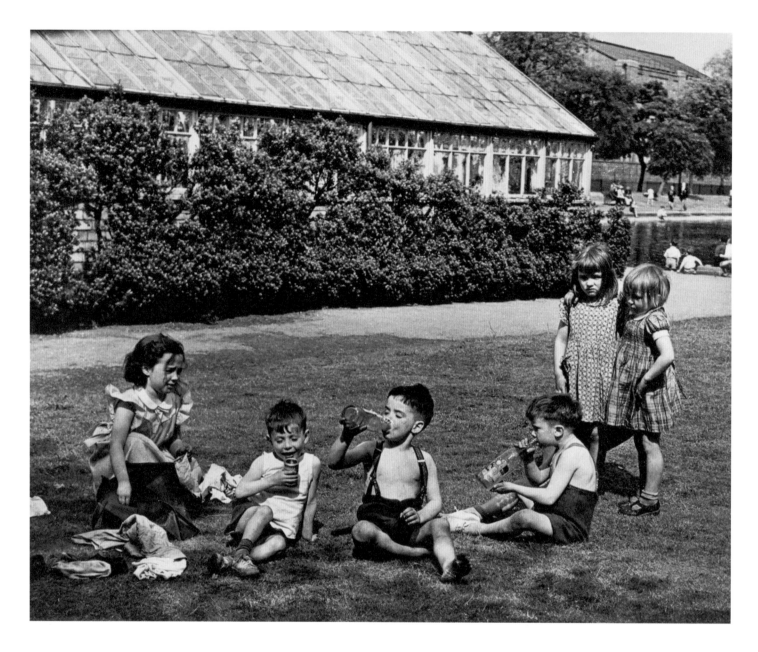

Elder Park
James Hagan
Glasgow South Co-operative Club

This group of small children has set out to enjoy the sunshine near the boating pond in Elder Park, Govan. However, the girls look on unhappily as the boys keep their bottles of ginger – sweet fizzy drink – to themselves. The summer of 1955 was very hot, and Glasgow's many parks were a popular destination.

OG.1955.121.[55]

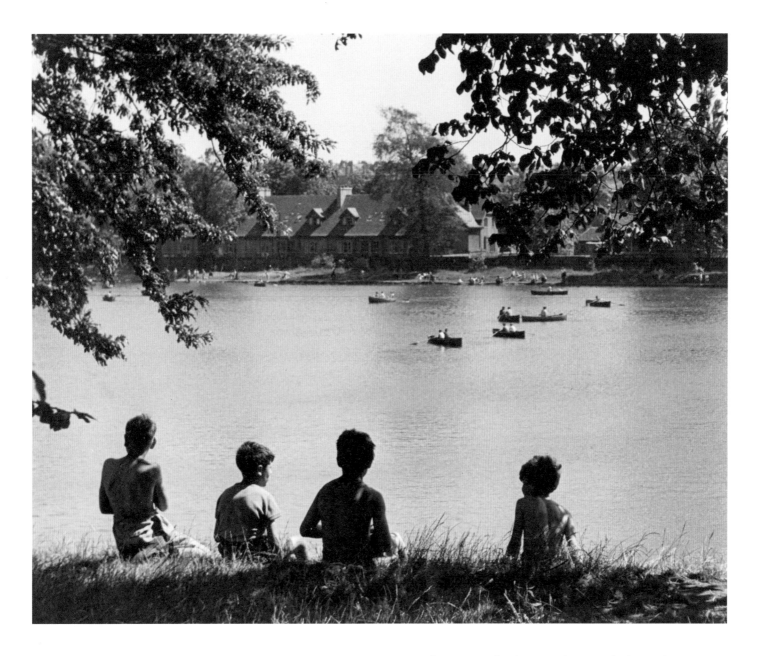

The Boating Pond, Great Western Road
Alex Lawson
Knightswood Camera Club

What better way to enjoy a hot summer's day than at Bingham's Pond? The pond was created in the 1880s, and took its name from the Bingham family who hired out boats in the summer and organized skating in winter. The site was sold a year after this photograph was taken. The eastern end of the pond was filled in and a hotel was built on it.

OG.1955.121.[43]

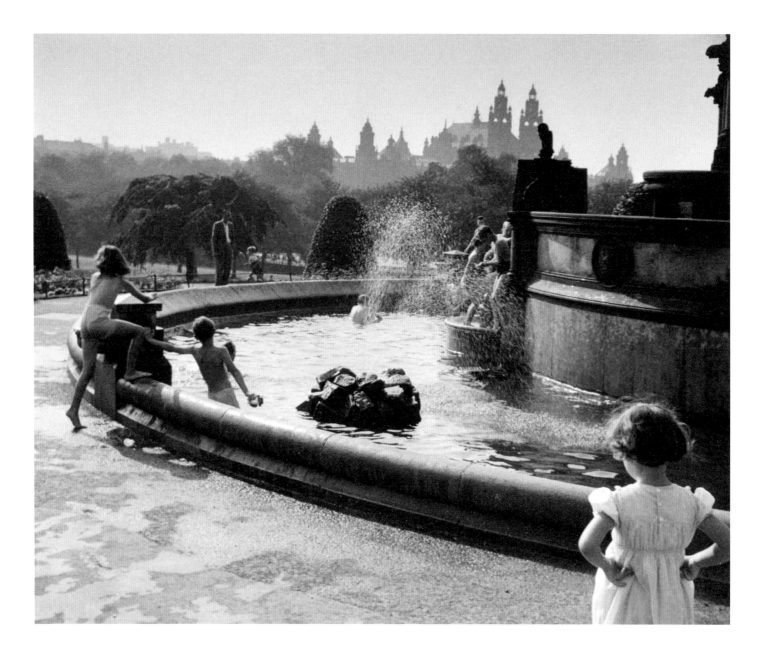

■ **The Fountain, Kelvingrove Park**
GC McColl

Partick Camera Club

Cooling off in the Stewart Memorial Fountain in Kelvingrove Park in Glasgow's west end. The fountain was built in 1872 as a tribute to Lord Provost Robert Stewart. He was responsible for the project to supply the city with clean water from Loch Katrine in the Trossachs. The distinctive outline of Kelvingrove Art Gallery and Museum can be seen on the skyline.

OG.1955.121.[180]

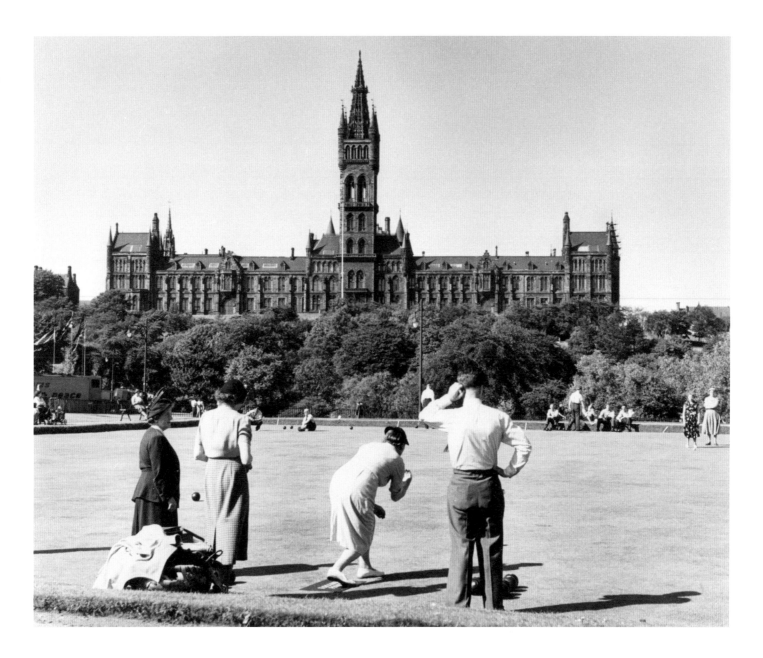

Bowling in Kelvingrove
C Jamieson
Partick Camera Club

This summer scene has changed little since the photograph was taken. Apart from the style of clothing, it could be a scene from this summer, as bowling in Kelvingrove Park is still a popular pastime.

OG.1955.121.[337]

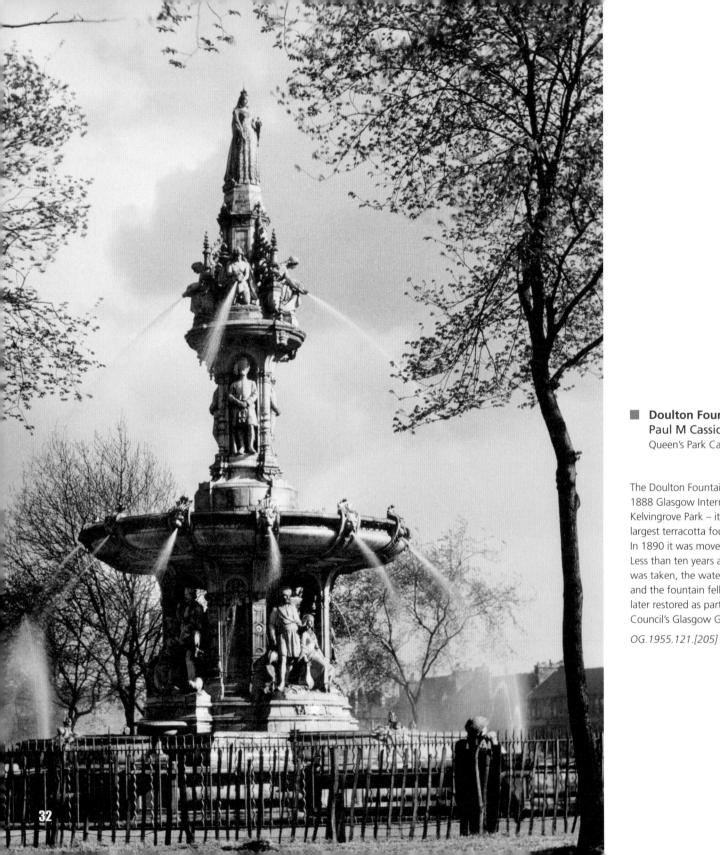

■ **Doulton Fountain**
Paul M Cassidy
Queen's Park Camera Club

The Doulton Fountain was a feature of the 1888 Glasgow International Exhibition in Kelvingrove Park – it is thought to be the largest terracotta fountain in the world. In 1890 it was moved to Glasgow Green. Less than ten years after this photograph was taken, the water was switched off and the fountain fell into disrepair. It was later restored as part of Glasgow City Council's Glasgow Green Renewal Project.

OG.1955.121.[205]

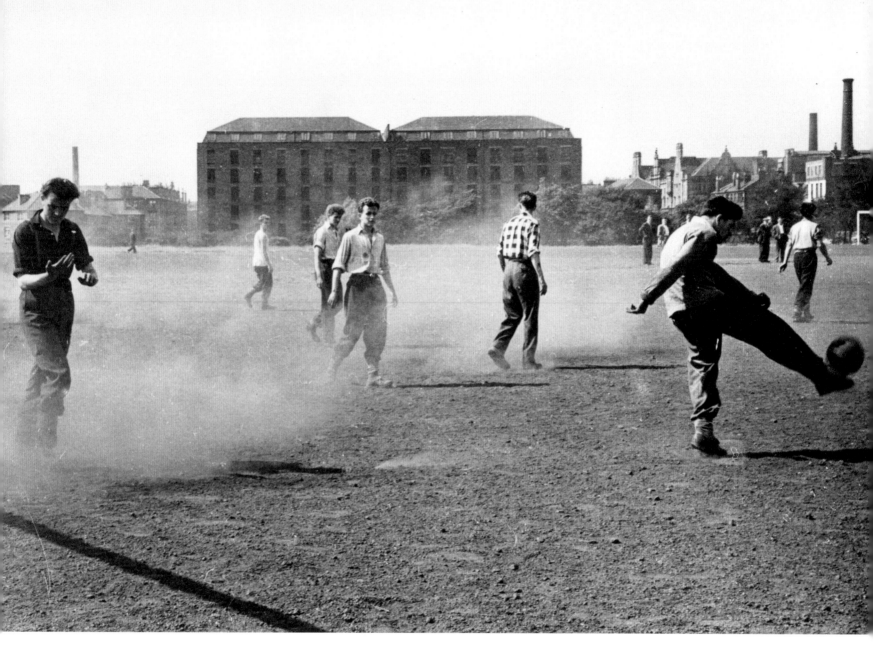

■ **Football on Glasgow Green**
Photographer and club unknown

Glasgow Corporation maintained a large number of football pitches at Flesher's Haugh on Glasgow Green. The pitches were surfaced with black ash and subsequently laid with red blaes (gravel). This photograph shows just how dusty and unpleasant conditions could become. The blaes pitches were closed in 1992, and in 2000 the Glasgow Green Football Centre opened in their place, with synthetic and grass pitches.

OG.1955.121.[272]

WORK

"I remember the shipyard horns and thousands of men going to work, the streets were so crowded, all carrying their pieces and tea and sugar tins. At every ship launch we were taken out of school, given flags and had to wait for hours to "wave" to the Queen. We always had the best view in front of the pavement."

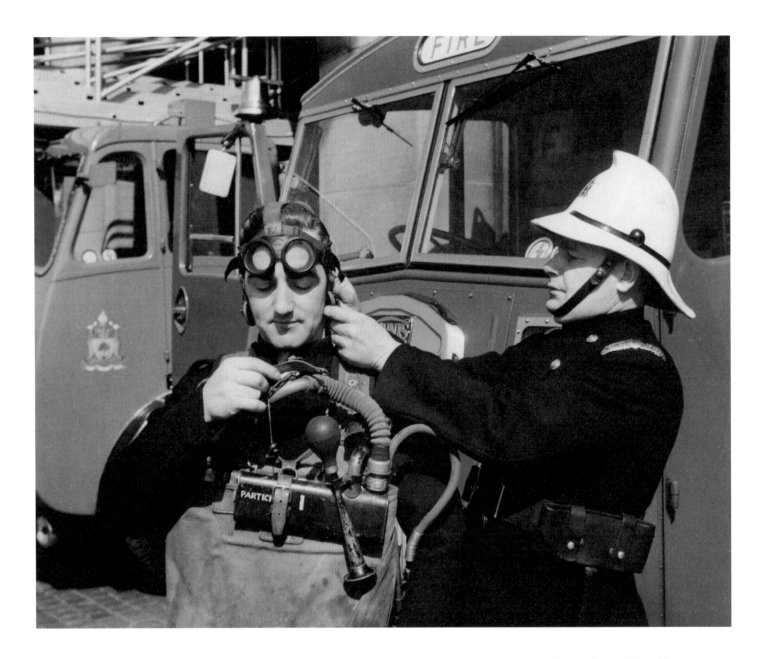

Glasgow Fire Service
Alf Daniel
Partick Camera Club

A fireman at Partick Fire Station appears to be being trained in the use of an early breathing apparatus set by a fire officer. These were complicated and cumbersome and the wearer needed assistance to put them on. Once the mouthpiece was inserted, firemen could only communicate using the 'pip horn' attached to their front. The number of pips indicated whether to move forward, backward or to stop. The men are beside a Dennis Pump Escape fire engine, while further back is a wartime issue Leyland Beaver Turntable Ladder. You can see that fire engines at this time still used bells as a warning device.

OG.1955.121.[111]

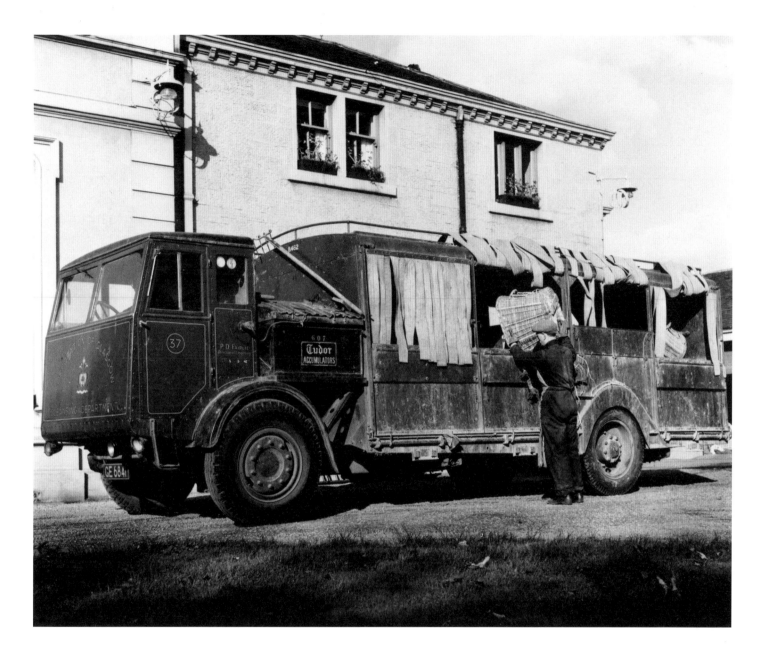

■ **Cleansing Department Collecting Rubbish with a Battery-driven Vehicle**
HB Coventry
Partick Camera Club

A battery-driven vehicle uplifts rubbish from an unknown location. The type of wicker basket being used by the man had been in use since the late 19th century for the same purpose. Today, Glasgow City Council uses vehicles powered by liquefied petroleum gas (LPG) or electricity for refuse collection. Rubbish is now put out for collection in wheelie bins.

OG.1955.121.[162]

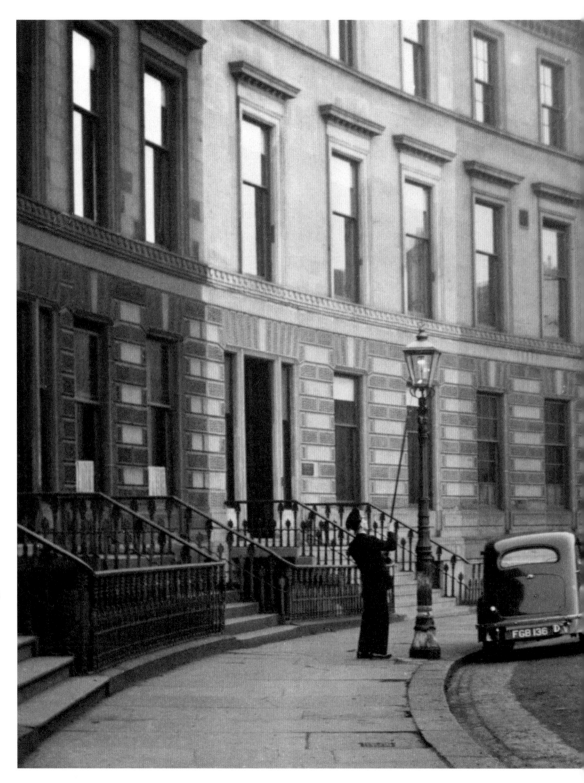

■ **'Lichtie' – Gas Lights in Park Circus**
Hugh MacDonald
Scottish Ramblers Association

This shows a lamplighter, known as a 'lichtie' or 'learie', on his daily round, lighting a gas street lamp. Many gaslights in Glasgow had to be lit manually, and the 'Lichtie' normally carried a small wooden ladder over one shoulder to help him with his tasks. Gaslights were still in use in some Glasgow tenements as late as 1987.

OG.1955.121.[210]

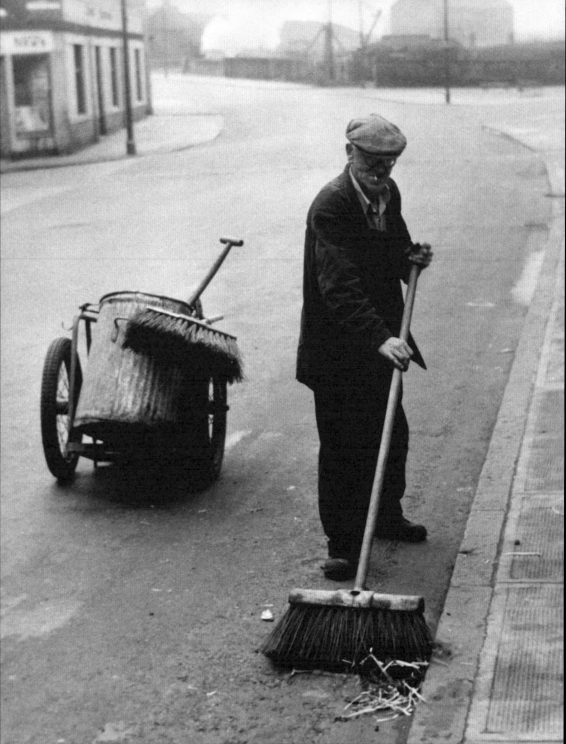

A Dawn Duty – Road Sweeper
Alf Daniel
Partick Camera Club

A cleansing department employee manually sweeps the roadside. From the late 1800s bins were often embedded in the pavements for road sweepings. In 1955, road debris still included a regular quantity of horse manure.

OG.1955.121.[292]

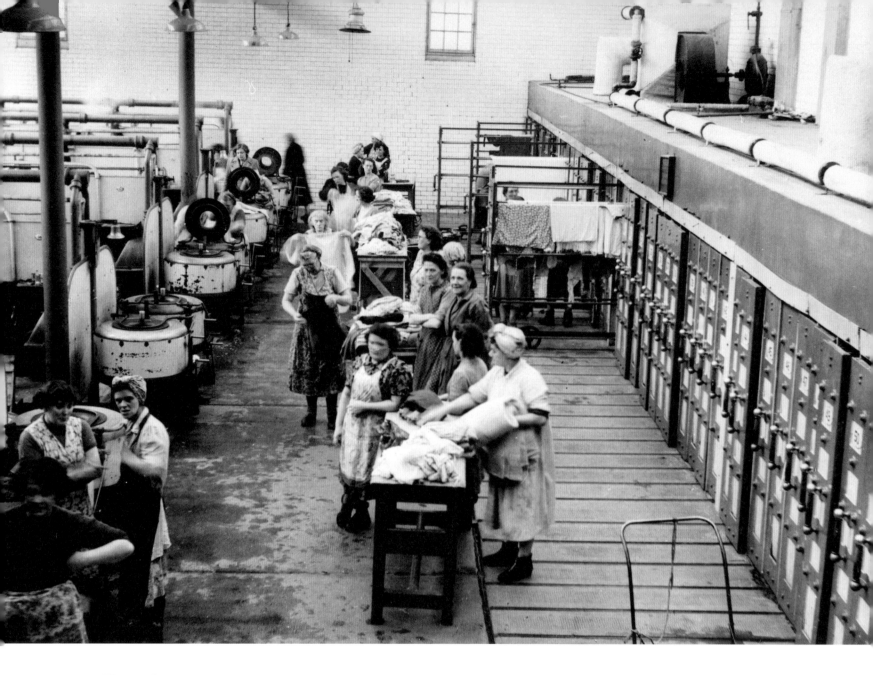

Partick Steamie
Alf Daniel
Partick Camera Club

This shows the interior of the Partick steamie, or washhouse, where the weekly wash was done. On the left are stalls where clothes were washed by hand. The adjacent circular drums were used for spinning water from the clothes. On the right are rows of driers – the rear ones are open and loaded with clothes ready to be dried. By 1955 there were also laundrettes where washing could be done in fully automatic machines.

OG.1955.121.[121.a]

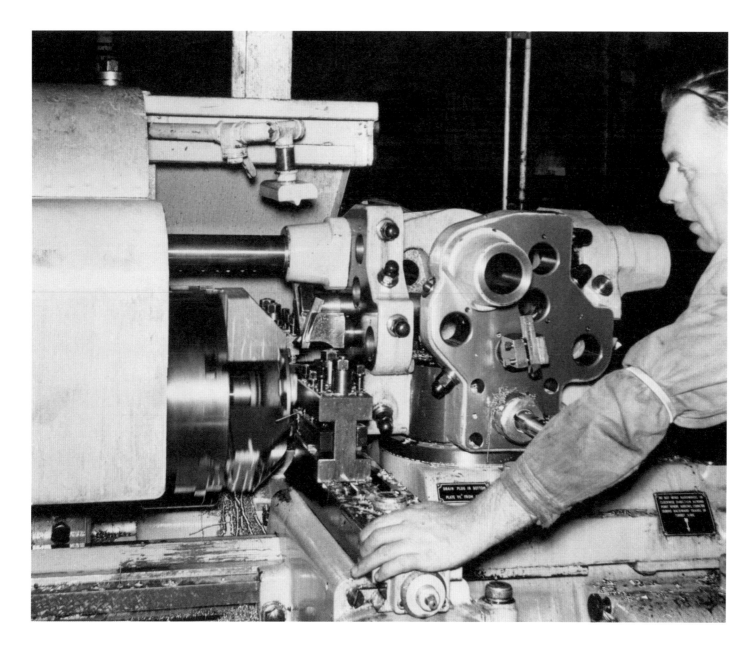

Interior, Albion Works, Scotstoun
James Logan
Partick Camera Club

Here an operator is shown at work on an automatic turning lathe. While some safety precautions have been taken with the man's sleeves, there is no other visible protective equipment. Heavy industry and manufacturing still figured in many people's working lives in 1955, and the resulting products were often exported globally across the British Empire.

OG.1955.121.[197.b]

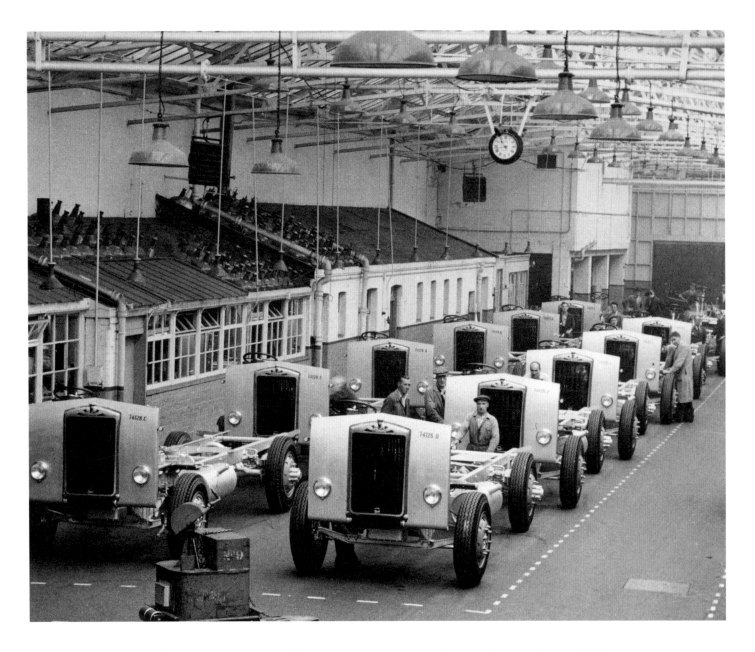

■ **Interior, Albion Works, Scotstoun**
James Logan
Partick Camera Club

The Albion Motor Car Company specialized in lorries and goods vehicles. This view is of part of the final assembly line. These chassis were used for flat-bed or drop-side trucks. Road vehicles had been manufactured in Glasgow since the late 19th century, but today road vehicles are no longer built in the city.

OG.1955.121.[197.c]

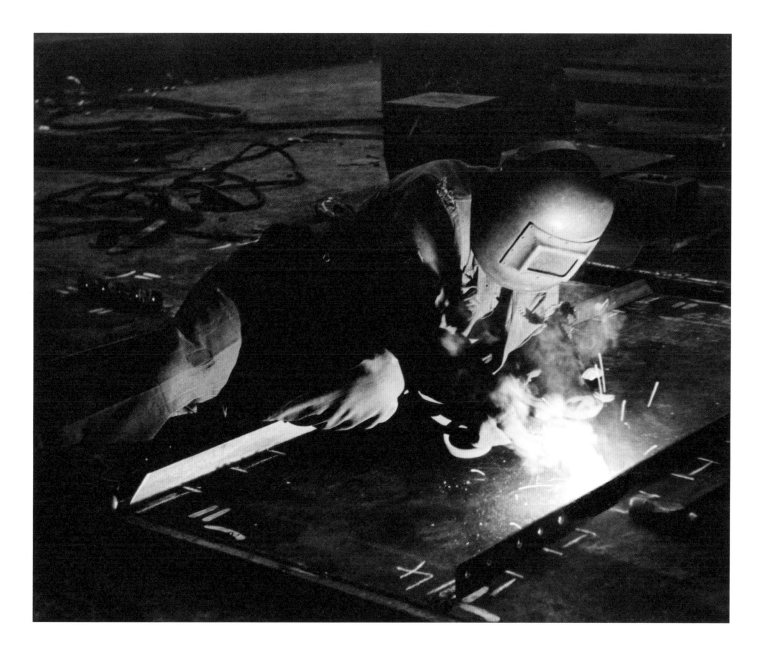

■ **Welder, Yarrow & Co.**
GC McColl
Partick Camera Club

A welder works on fabricating a section of ship in Yarrow's shipyard, Scotstoun. In 1955 the company began a five-year plan to modernize the yard to increase efficiency and remain competitive. This included prefabrication workshops, where 40-ton (40.64 metric tons) ship sections could be welded together before being assembled in the yard's building berths. Welding was belatedly introduced to the Clyde shipyards during World War II to help improve productivity.

OG.1955.121.[232]

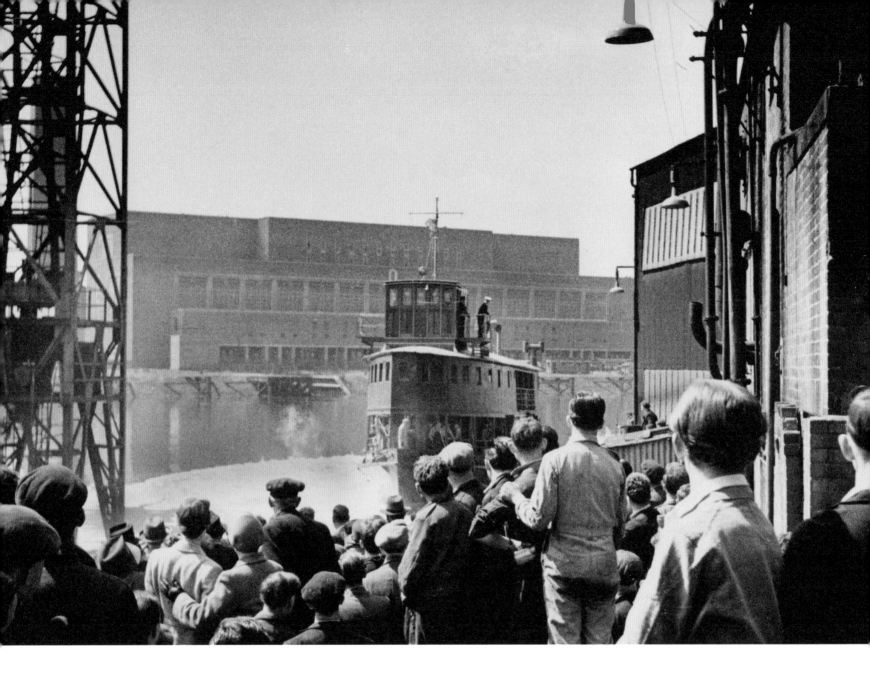

Launch of River Vessel at Yarrow's Yard, Scotstoun
GC McColl
Partick Camera Club

Crowds at Yarrow Shipbuilders, Scotstoun, watch the launch of a vessel destined for South America. The photographer caught the excitement of the launch as, slowed down by drag chains, the boat slides towards the water. The vessel is the *Rocafeurte*, built by Yarrow for the Peruvian government. Yarrow & Company moved to the Clyde in 1906 from London, and is now part of BAE Systems.

OG.1955.121.[118.b]

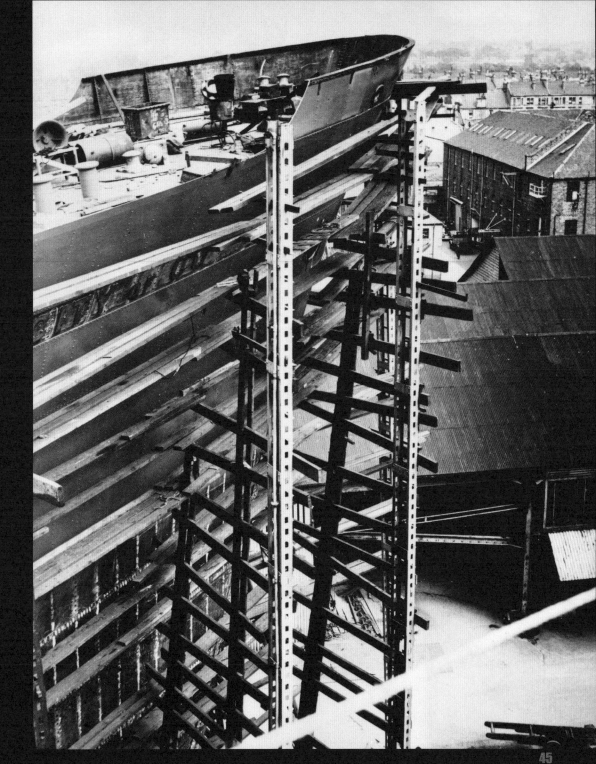

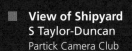 **View of Shipyard**
S Taylor-Duncan
Partick Camera Club

The *City of Colombo* towers over Barclay Curle's
shipyard and surrounding tenements as she
nears completion, giving an idea of the size of
vessel built on the Clyde. This would have been
a familiar scene along parts of the river.

OG.1955.121.[237.a]

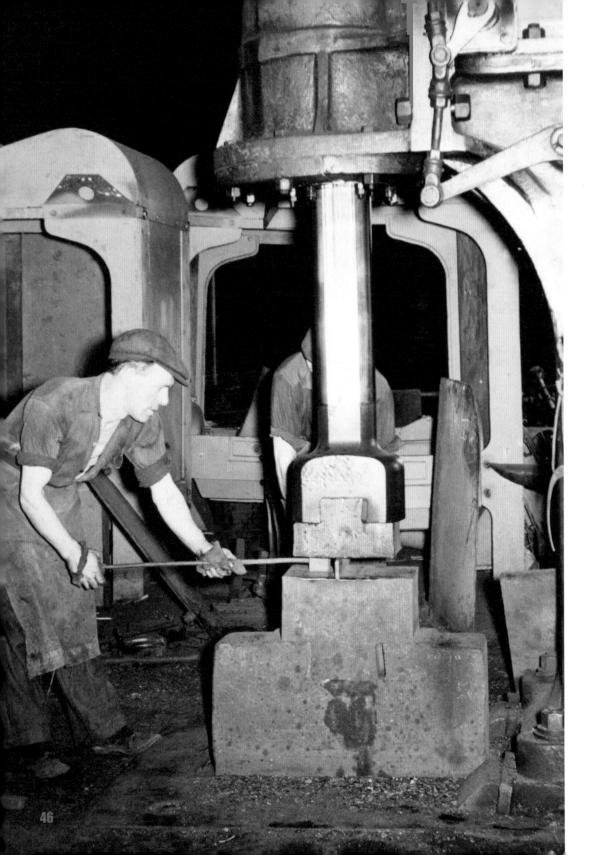

View of Shipyard – Blacksmith's Shop
S Taylor-Duncan
Partick Camera Club

In what must have been a noisy scene, a blacksmith and his team operate a steam hammer. Three men work the half-ton hammer – the blacksmith is partly hidden by it, but the hammer-man is clearly seen on the left of the photograph. Not shown is the hammer-driver, who would be sitting or standing on the right. As the men were not supplied with gloves, the hammer-man uses canvas 'haun rags'. At the age of 14, apprentices began to learn how to use the steam hammer, eventually being skilled enough to delicately close a matchbox with it.

OG.1955.121.[237.b]

■ **View of Shipyard – The Riveter**
S Taylor-Duncan
Partick Camera Club

This would have been a common scene in the
Clydeside shipyards in 1955. Riveting was the
main method of joining metal plates in iron and
steel shipbuilding before welding was introduced.
The riveter uses a pneumatic rivet gun to secure
the rivets in place. Despite the noise, shipyard
workers were not issued with any ear protection,
and most riveters became deaf. Many were also
affected by vibration white finger, a painful and
potentially disabling condition affecting the hands
and fingers, caused by working with hand-held
vibrating machinery.

OG.1955.121.[237.c]

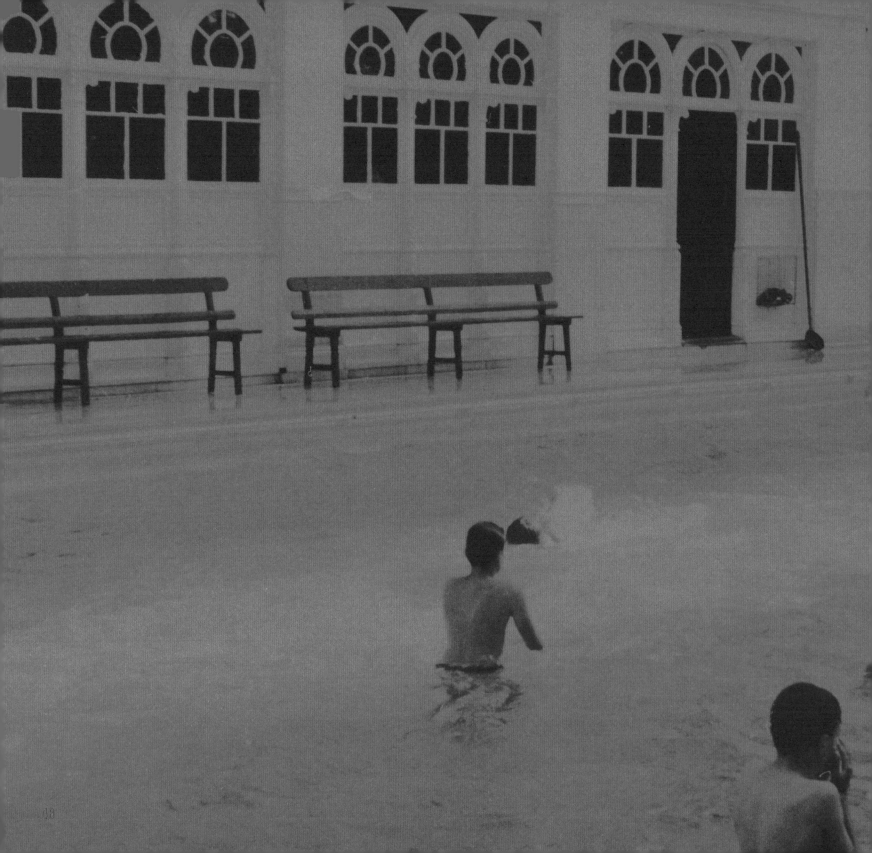

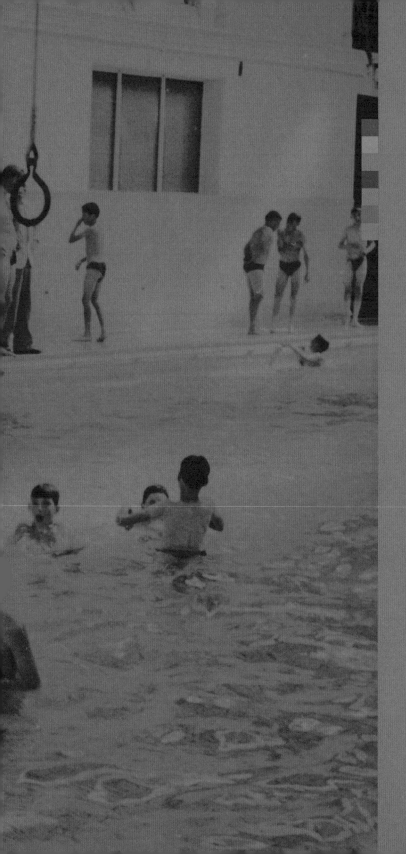

AT GLASGOW 1955: THROUGH THE LENS
PLAY

> I was born in Bridgeton, May 1955. Lived on top floor tenement. Remember ABC Minors Cinema at Bridgeton Cross every Saturday morning. "Jenny Petries" shop and her cider ice-lollies. Walking to "the Shows" at Glasgow Green. Seemed to take ages to get there, and the building excitement. Taking rags to rag man for a balloon. Sixpence pocket money on a Friday. Buying American comics. Swapping scraps on the stairs.

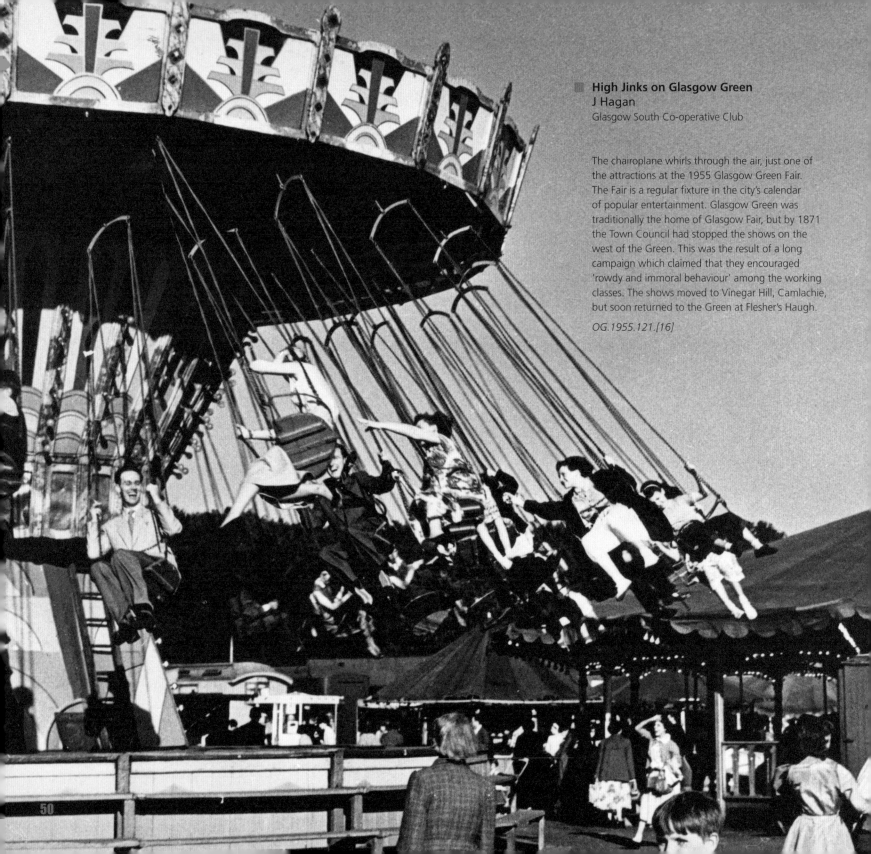

High Jinks on Glasgow Green
J Hagan
Glasgow South Co-operative Club

The chairoplane whirls through the air, just one of
the attractions at the 1955 Glasgow Green Fair.
The Fair is a regular fixture in the city's calendar
of popular entertainment. Glasgow Green was
traditionally the home of Glasgow Fair, but by 1871
the Town Council had stopped the shows on the
west of the Green. This was the result of a long
campaign which claimed that they encouraged
'rowdy and immoral behaviour' among the working
classes. The shows moved to Vinegar Hill, Camlachie,
but soon returned to the Green at Flesher's Haugh.

OG.1955.121.[16]

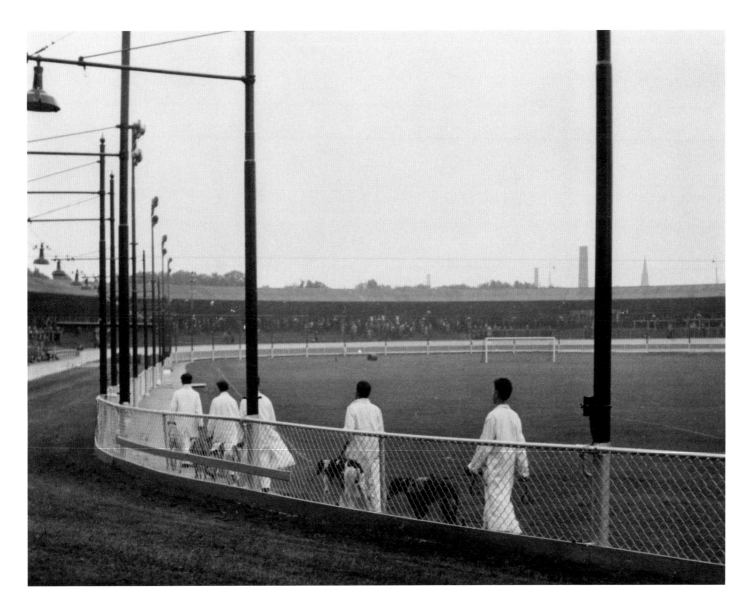

Parading the Track, Shawfield Park
Hugh MacDonald
Scottish Ramblers Association

Greyhounds are paraded in front of spectators before racing around the floodlit track on the outside of the football pitch. Greyhound racing was introduced to Britain from the USA in 1926, and 'the dogs' quickly became popular. Shawfield Park had been the home of Clyde FC, and to raise money the club introduced greyhound racing in 1932. This was so successful that the Shawfield Greyhound Racing Company eventually took over the stadium. Greyhound racing still takes place at Shawfield Park.

OG.1955.121.[228.b]

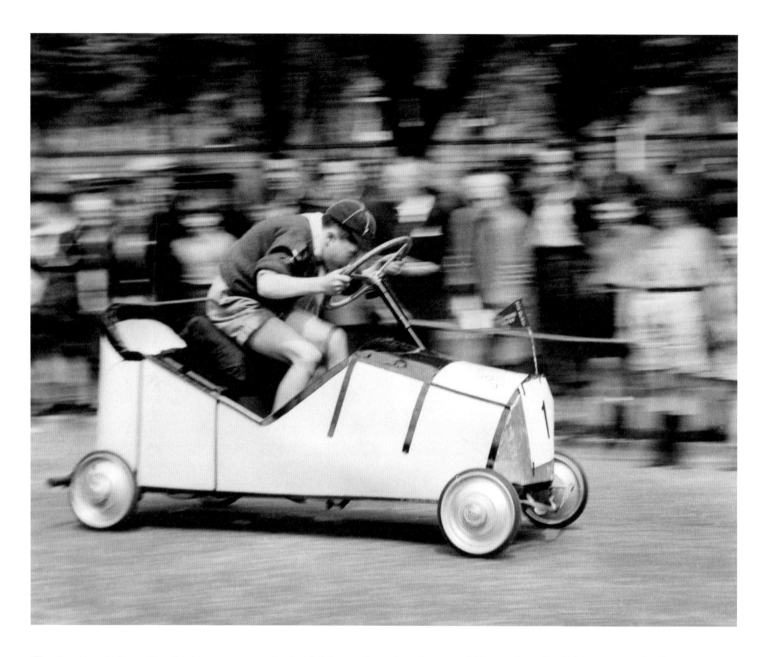

■ **Boy Scouts Soap Box Derby**
Photographer and club unknown

Boy Scouts take over the main carriageway of Glasgow Green for their Soap Box Derby of 1955. Local Scout groups designed, built and raced their own pedal cars at the derby. The cars had to be made for 50 shillings (£2.50) or less. The Soap Box Derby was first introduced to Britain in 1939 from the USA, and in 1962 it was renamed the National Scoutcar Races. It is still going strong today.

OG.1955.121.[265.c]

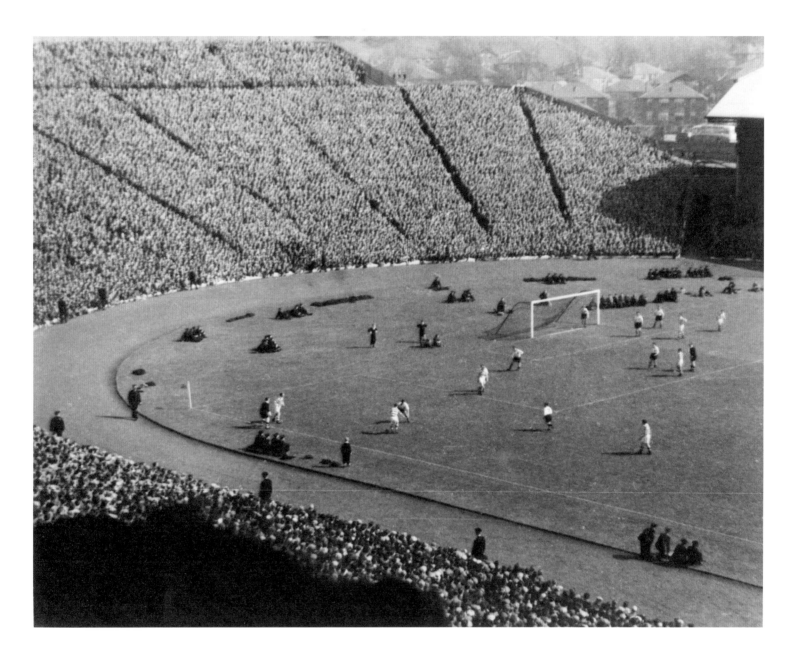

■ **Scottish FA Cup Final**
James Henderson
Scottish Ramblers Association

Two Glasgow clubs, Celtic and Clyde, play in the 1955 Scottish FA Cup final at Hampden Park. This was the first Scottish Cup final to be televised live. The photographer recorded that there was a crowd of approximately 130,000 people. The score was 1–1 and Clyde won the replay 1–0. The photograph was taken from the North Stand, which was opened in 1937, looking towards the East Terrace.

OG.1955.121.[21]

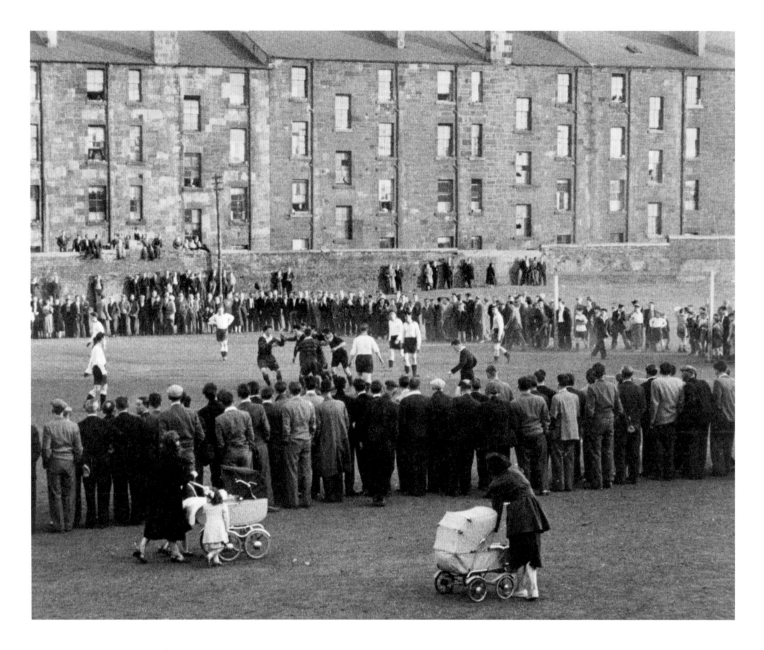

Glasgow Sports – Plantation
M Martin
Glasgow South Co-operative Club

A team celebrates a goal on the football pitches at Plantation Park, McLellan Street, south of the Clyde. Known locally as the 'plots', the two pitches were used by Park United and Avon Villa AFC and many church teams. Plantation, part of today's Kinning Park, took its name from the 18th-century estate of the Robertson family who made their money from their West Indies plantations. The name remained long after the grand mansion and grounds had gone.

OG.1955.121.[64]

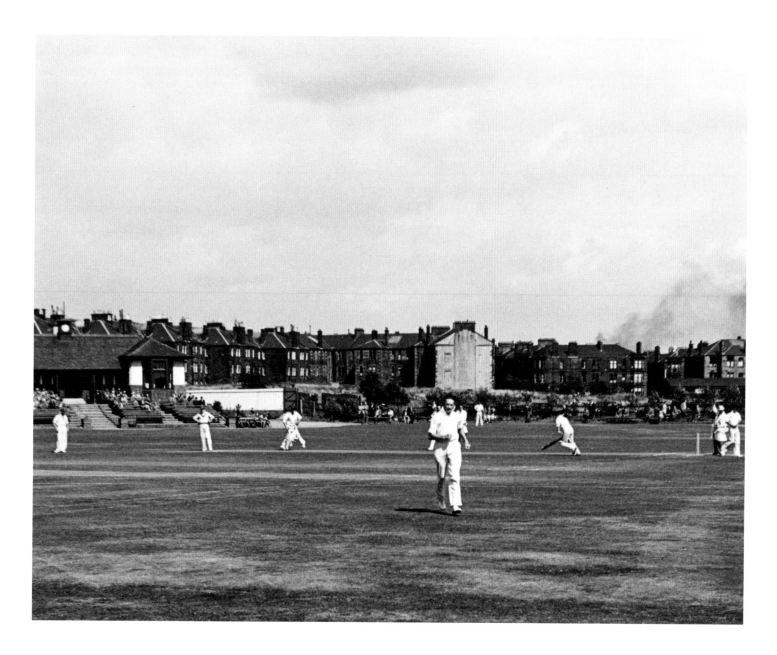

Impressions of a Cricket Match
Louis L Strachan
Dennistoun Camera Club

Clydesdale Cricket Club plays Poloc Cricket Club on 6 August 1955 at Clydesdale's home ground in Titwood. Although cricket was a popular working class sport in the first half of the 19th century, by the end of the century it had become a mainly middle class sport. Clydesdale CC was founded in 1848, making it Scotland's third oldest cricket club. In the 1870s the club sold its old ground in Kinning Park to a new football club, Glasgow Rangers, and moved to its present site. Today Clydesdale Cricket Club still maintains a full size international cricket ground.

OG.1955.121.[303.a]

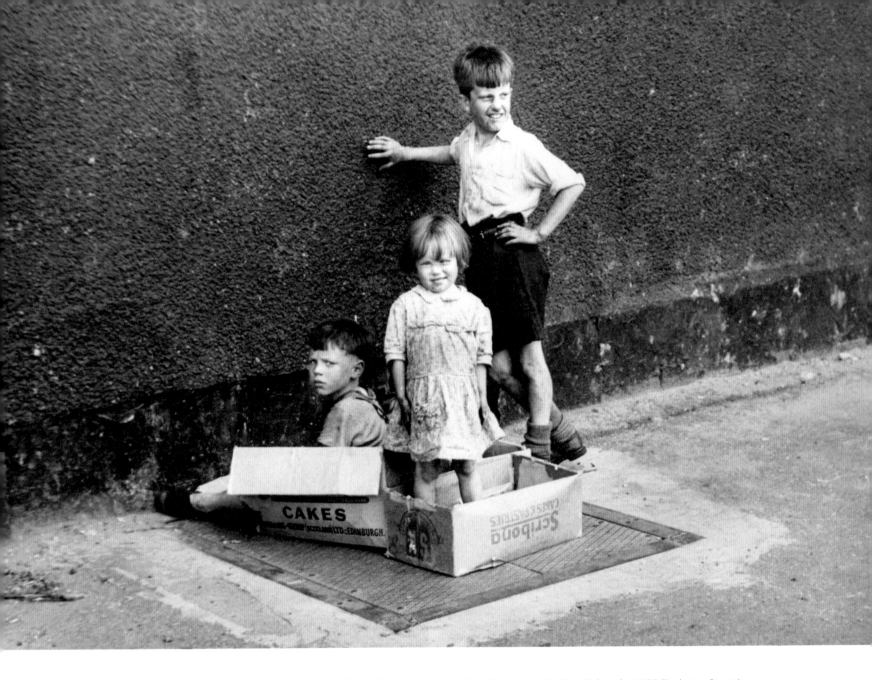

The Wonderful World of Make-believe
Thomas Robertson
Partick Camera Club

Three children play with cardboard boxes outside Dirty Dicks pub at 175 Finnieston Street in July 1955. Being close to the docks, the pub was a favourite with dockers and sailors of all nationalities. Dirty Dicks served tea and hot food as well as alcohol, and accepted foreign currency as payment. The pub and the tenement block it was part of were demolished in the 1960s as part of the Highways Plan, which included the construction of the Clyde Expressway.

OG.1955.121.[229.b]

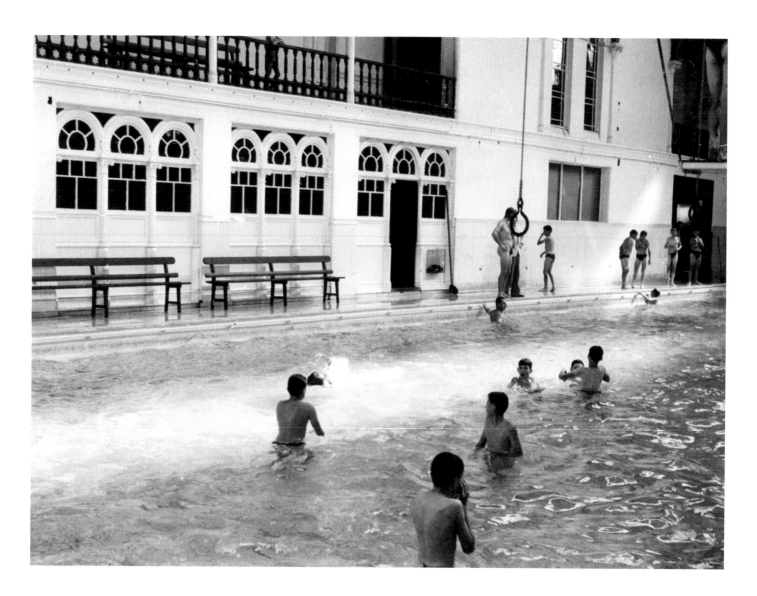

View of the Western Baths, Hillhead
Thomas Robertson
Partick Camera Club

These boys enjoy a swim in the pool at the Western Baths, Cranworth Street, in July 1955. 'The Baths' have become something of a Glasgow institution over the years. Founded in 1876 by subscription, it is one of two remaining private swimming baths in Glasgow from the five founded in the late 19th century. This photograph clearly shows one of the baths' famous travelling rings and trapeze, which run the length of the pool.

OG.1955.121.[404.c]

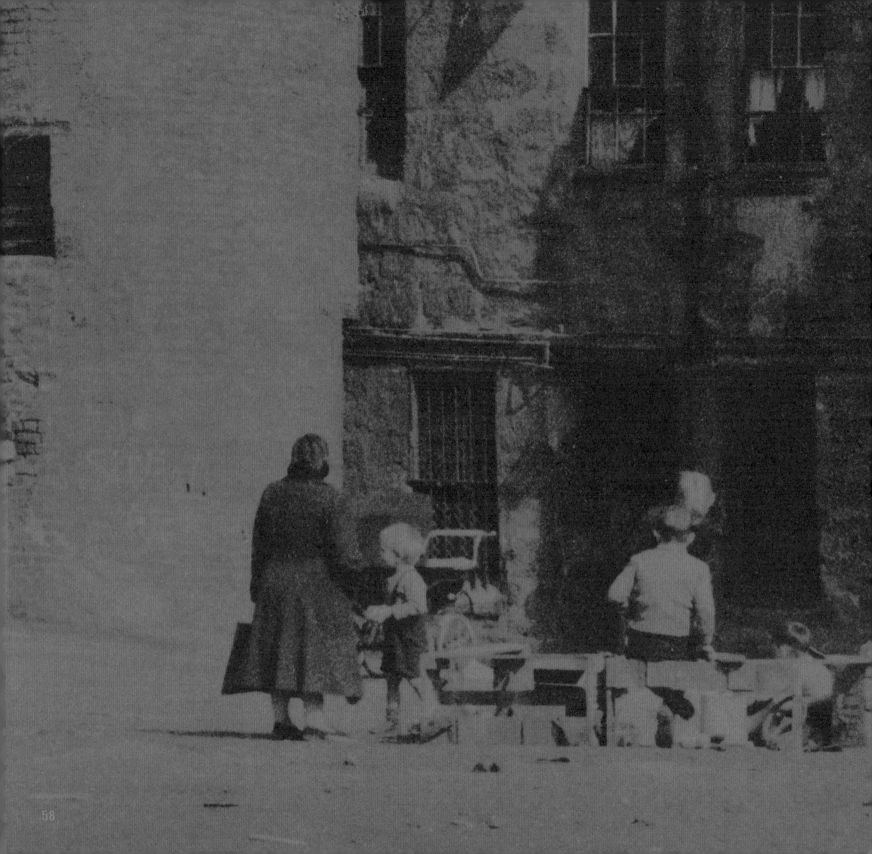

HOME
GLASGOW 1955: THROUGH THE LENS

" I was born in 1940 and lived in a
"single end" until I was 9 or 10 (4 of
us in one room for sleeping, eating,
cooking, etc). Went to "the steamie"
for a hot bath once a week! Moved to
Castlemilk in 1956 – oh the luxury of a
proper bathroom! "

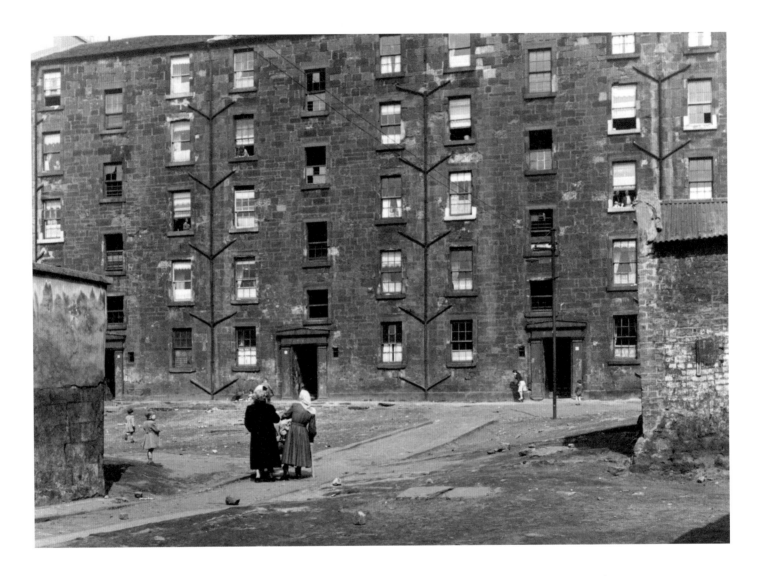

Tenement, George Street
Bill Tait
Partick Camera Club

These buildings were located to the east side of George Street, close to High Street. The blocks appear to be 'room and kitchen', or two-apartment, houses. The broken windows are the stairhead windows which have not been repaired by the factor, as was usually the case in poorer areas. Unusually, the close entrance is to the rear of the buildings.

OG.1955.121.[8]

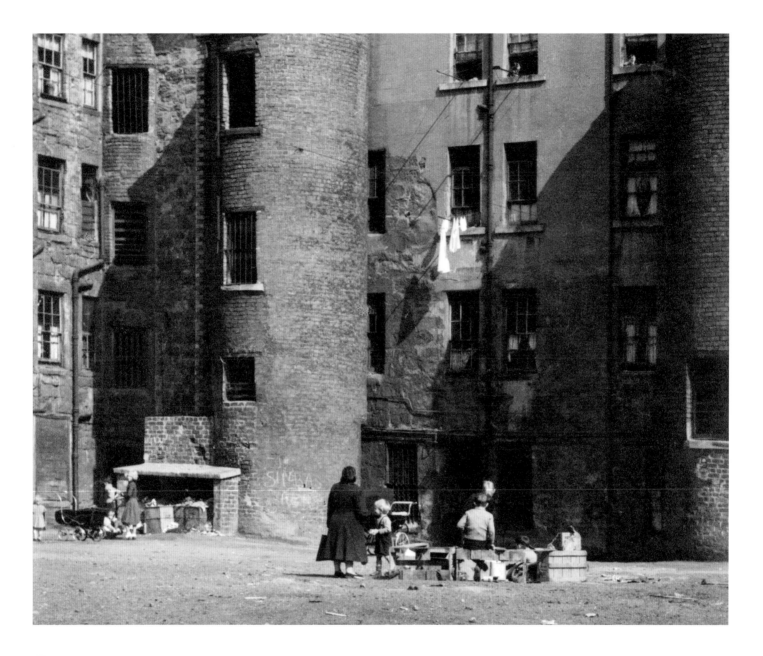

Gorbals Back Court, Adelphi Street
Photographer and club unknown

This scene captures the only playground many children had, but they were safe under the watchful eyes from many kitchen windows. These children have set up shop and are trading with items found lying on the ground. Inside the circular tower is the common stair for the tenement to the right of the image. Laundry can be seen drying outside a window, propped safely out of reach of the playing children – and the mud.

OG.1955.121.[380]

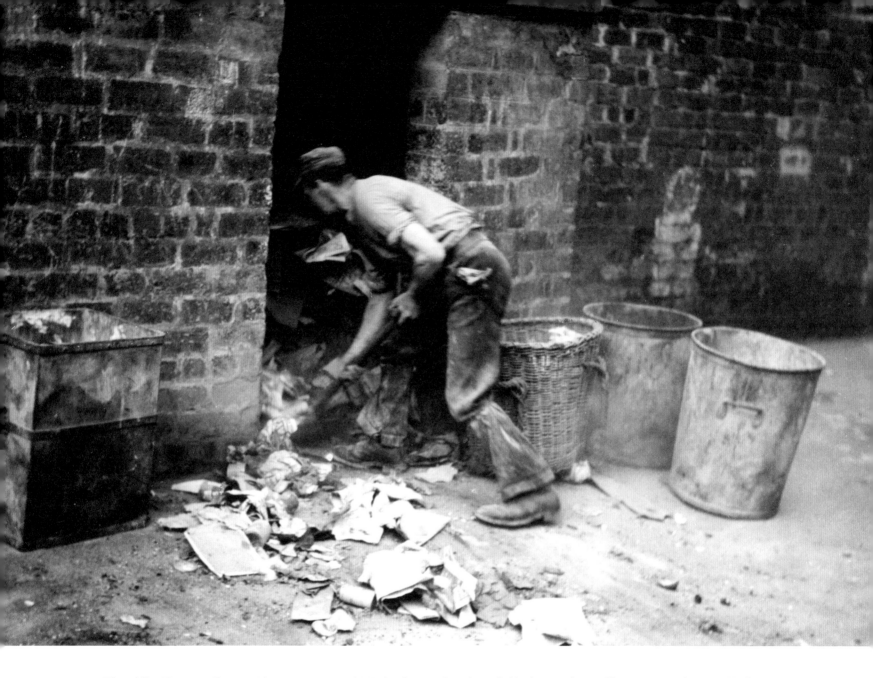

While Glasgow Sleeps – Binman
Alf Daniel
Partick Camera Club

In 2005, the photographer who took this photograph voiced his amusement that it could offer any valuable insight into life in 1950s Glasgow. He suggested it now be called, 'Nice view of a midden!' – a place to put rubbish. It is interesting to see there is no glass or plastic in the rubbish the man is shovelling. The binding under his knees is to prevent vermin running up his trouser legs.

OG.1955.121.[291]

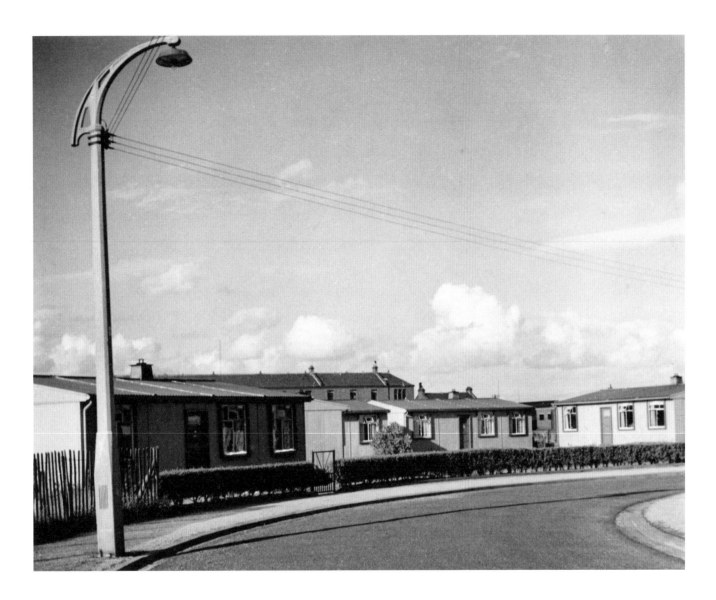

■ **Prefabs at Torbreck Street**
Hugh MacDonald
Scottish Ramblers Association

This shows prefabricated houses, or 'prefabs', at Torbreck Street in Craigton. These metal-framed houses were built under the Housing (Temporary Accommodation) Act of 1944 to reduce pressure on the ageing housing stock in Glasgow, and to replace houses that had been destroyed during World War II. Despite having a limited life expectancy, prefabs became popular and some can still be seen in modified form today.

OG.1955.121.[92]

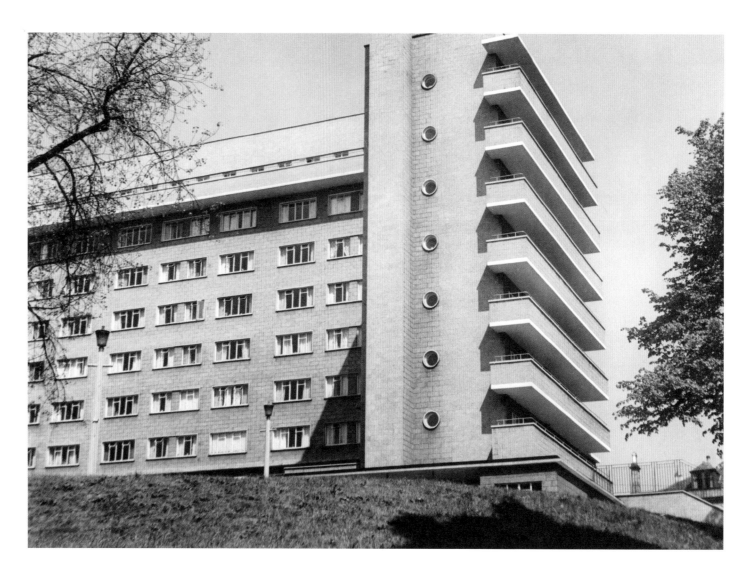

■ **Spinster Flats**
Alf Daniel
Partick Camera Club

These flats are at Crathie Court, Thornwood. Built between 1949 and 1952 by Glasgow City Council, the scheme housed single women and was the first of the City's high-rise housing. It was awarded the Saltire Award for architectural merit, and was closely followed by the second of Glasgow's high-rise flats to be built – Moss Heights, near Hillington.

OG.1955.121.[179]

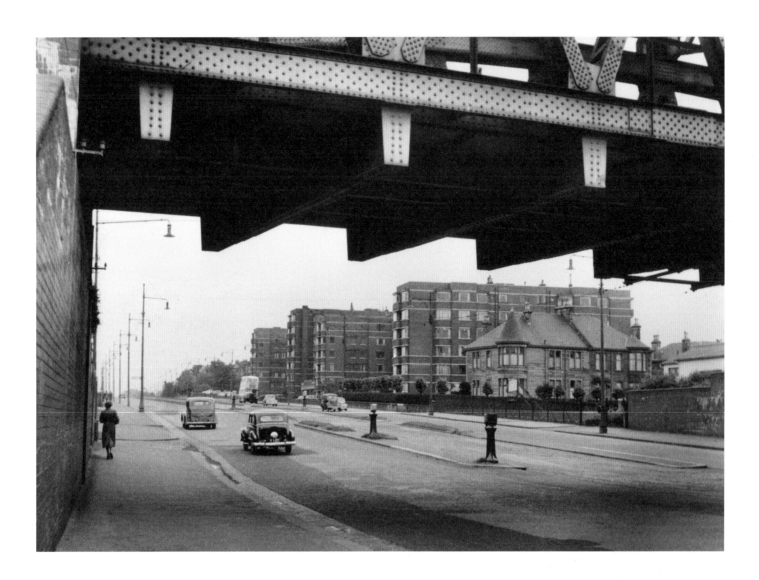

■ **Luxury Flats, Great Western Road**
Margaret Finlayson
Partick Camera Club

This view is looking southeast from Anniesland Station towards Kelvin Court. Built in 1937–38, these flats offered a combination of an Art Deco frontage with the luxury of separate garage space and modern internal conveniences. The level of traffic may indicate that the photograph was taken either early in the morning or on a Sunday. The flats are still there today, and remain a desirable address.

OG.1955.121.[100]

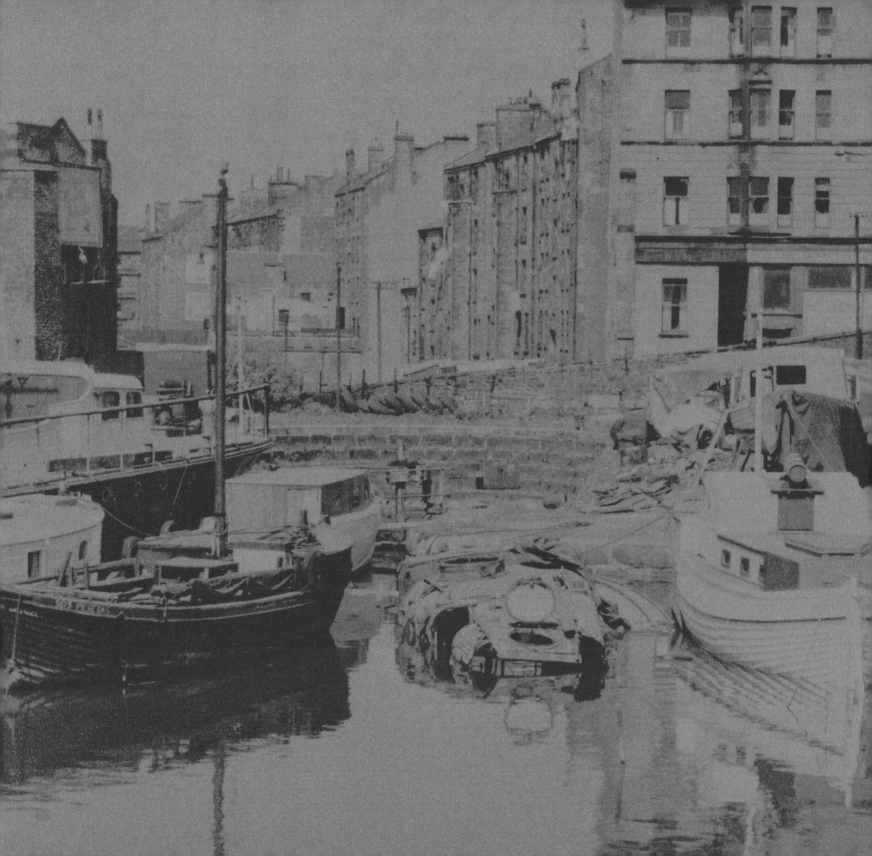

CANALS GLASGOW 1955: THROUGH THE LENS

I remember the ditty "At Kelvin docks they built ships with their bow in Maryhill and their stern in Bowling".

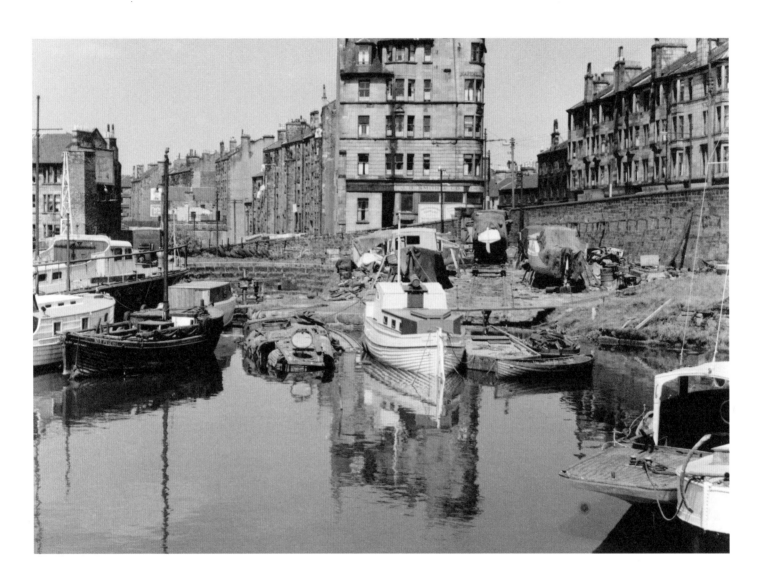

Repair Locks, Forth and Clyde Canal
LG Bates
Partick Camera Club

The Kelvin Dock, close to Maryhill Cross, was built as part of the Forth and Clyde Canal in 1790. The Swan family operated the dock as a shipyard from 1837. The first of the famous Clyde puffers, the *Glasgow,* was built there in 1857. From the 1920s to the 1950s the yard was operated by McNicoll Brothers who built landing craft for the navy during World War II. By the time this photograph was taken, the yard was operating only as a repair dock.

OG.1955.121.[65]

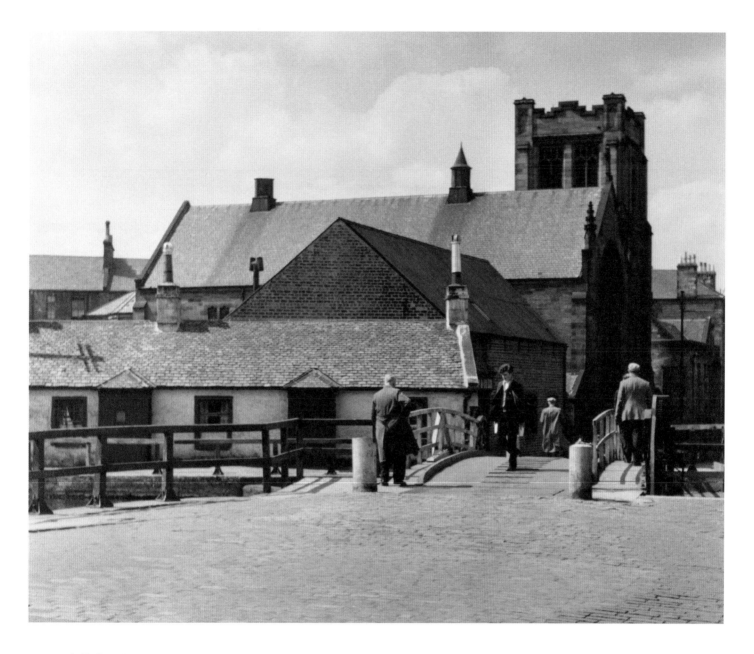

Ruchill Church
LG Bates
Partick Camera Club

Here you can see the canal keeper's lodge at the Forth and Clyde Canal in Maryhill. To the rear of the image is Ruchill Church on Shakespeare Street – its hall was designed by Charles Rennie Mackintosh. The lodge is now gone.

OG.1955.121.[69]

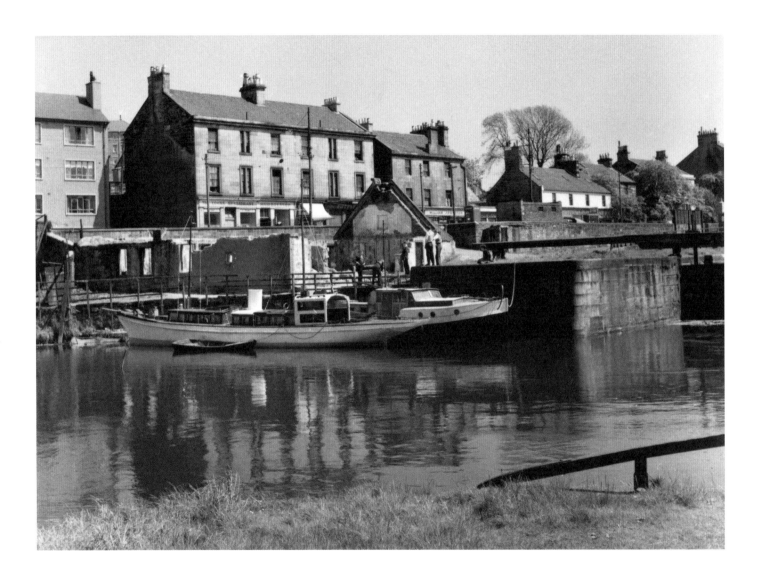

View of Forth and Clyde Canal at Maryhill
LG Bates
Partick Camera Club

The Forth and Clyde Canal was built between 1768 and 1790 to take seagoing vessels across the country, thus avoiding the hazardous route around the north of Scotland. This photograph shows vessels moored in a basin in the system of five locks, which brought the water up to its summit at Maryhill. By 1955 the canal was seldom used for commercial traffic and it closed in 1963. It was refurbished as the Millennium Link and reopened in 2001 for leisure traffic.

OG.1955.121.[355.d]

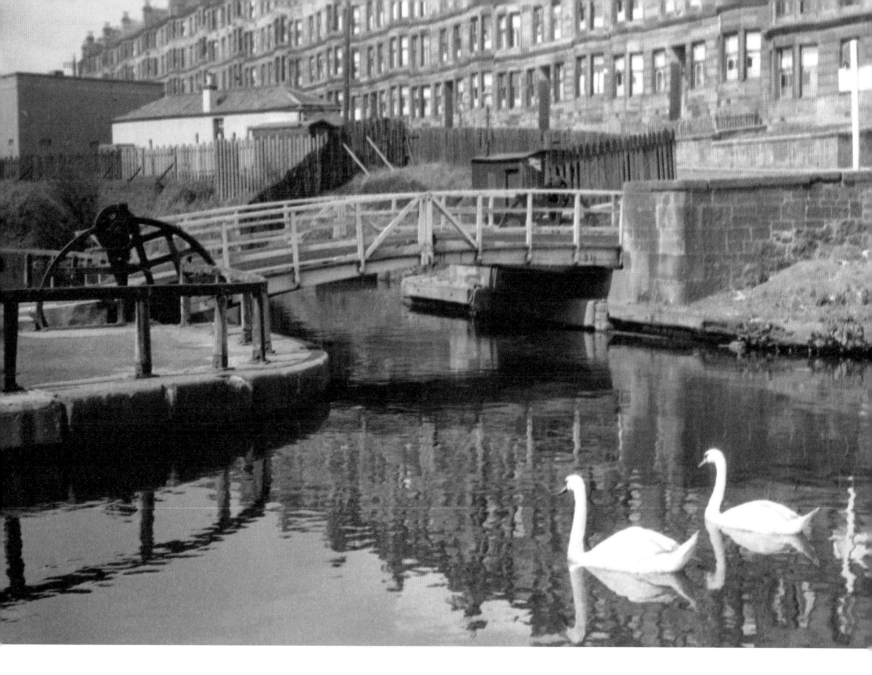

Forth and Clyde Canal at Firhill
Charles Nicol
Scottish Ramblers Association

This bridge over the canal is at Firhill Road, and the tenements to the rear are on Murano Street. The bridge was rebuilt in 1990, and is known locally as the 'Nolly Bridge'. The canal in Firhill was lined with iron works and extensive timber basins.

OG.1955.121.[239]

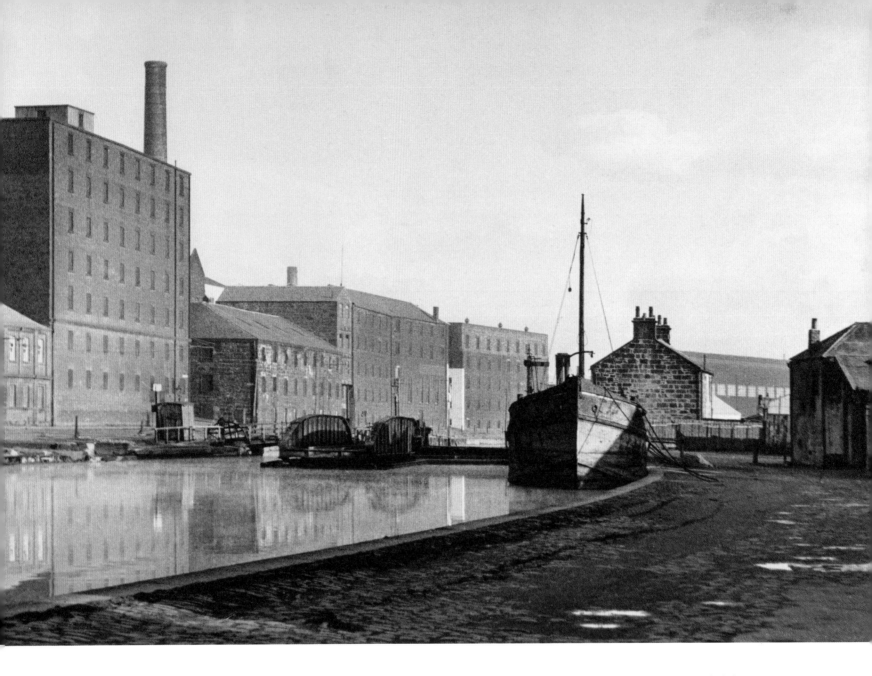

Spiers Wharf, Port Dundas
Bill Tait
Partick Camera Club

Port Dundas was named the principal port for Glasgow in 1791 when the Forth and Clyde Canal was extended from Hamiltonhill. The buildings shown here were warehouses, originally built in connection with iron and chemical works. By 1967 they were in use in connection with a distillery. Many of these buildings have now been converted into private flats.

OG.1955.121.[216]

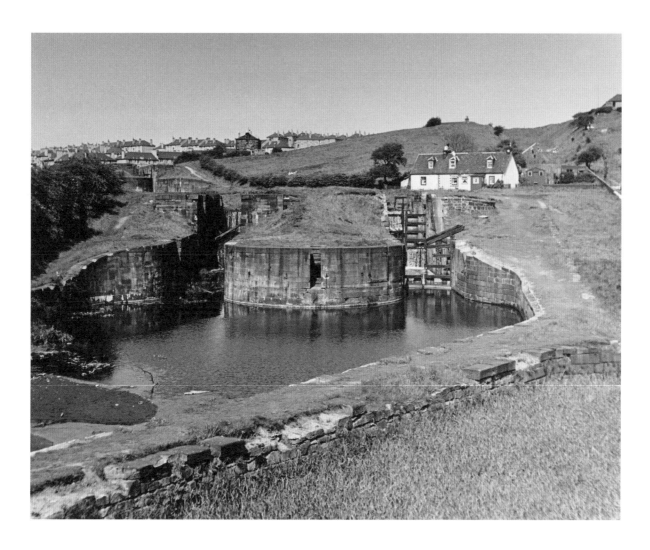

Blackhill Locks
Louis L Strachan
Dennistoun Camera Club

View looking northeast towards Blackhill. These locks opened in 1793, which allowed the Monkland Canal to be extended and bring coal into Glasgow. The canal closed to navigation in 1952, and much of it was later piped or filled in. The eastern section of the M8 motorway is built over part of the in-filled canal.

OG.1955.121.[328]

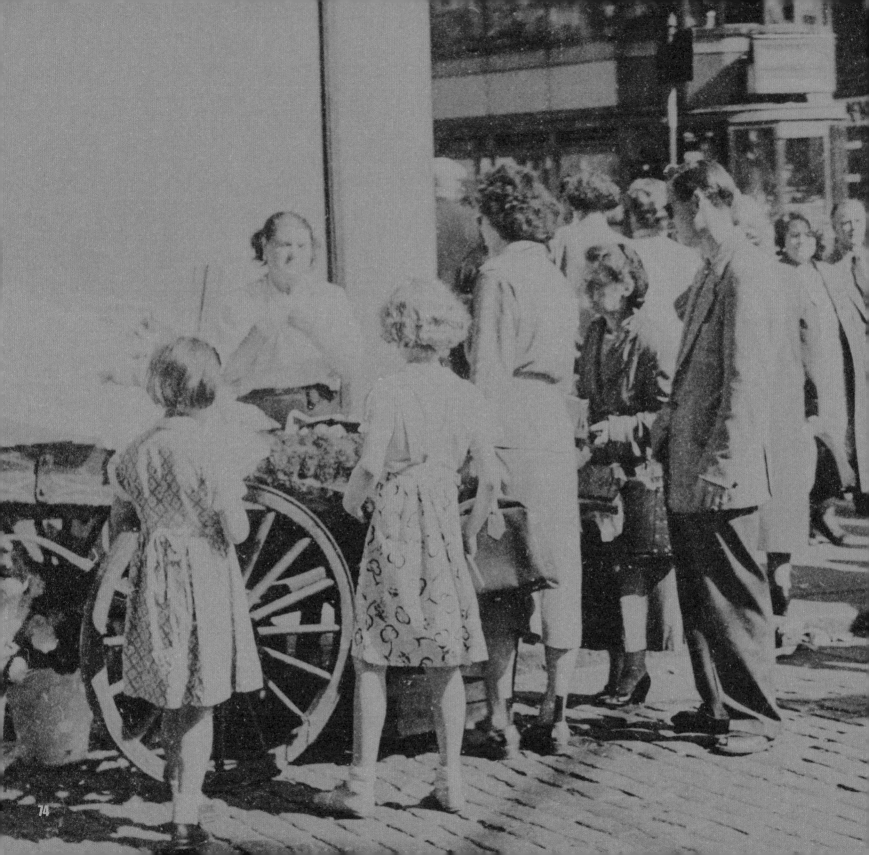

CHANGED DAYS

" How many times has that story been told by Weegies? Single end for four (washing in the sink beside the coal bunker) then move to a brand new flat (in our case Dennistoun to Cranhill). Bliss. Then away – in our case to Australia. "

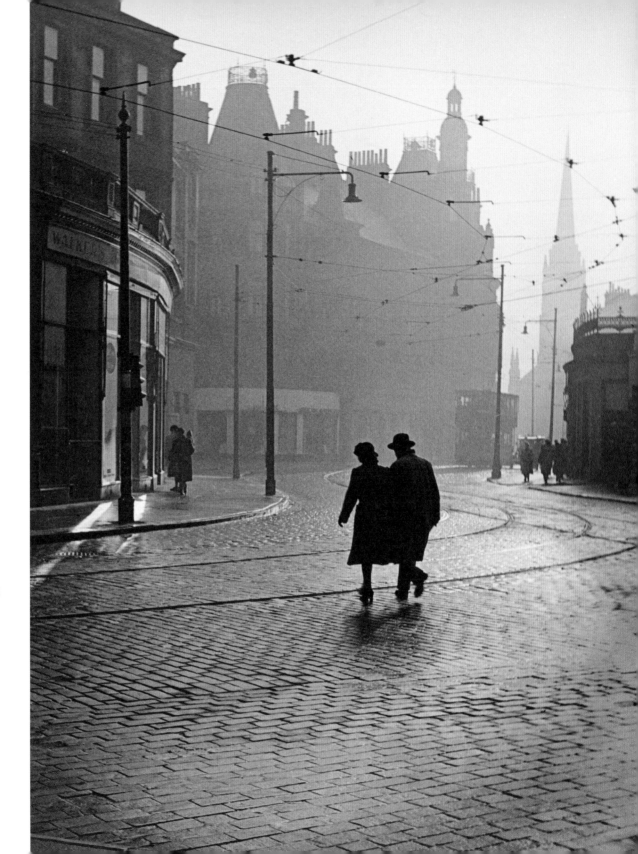

■ **Charing Cross –
A Morning Walk**
John S Logan
Scottish Ramblers Association

Looking south towards Charing Cross
Mansions, this street scene underwent
radical changes in the following ten
years. The construction of the inner ring
road, now the M8 motorway, removed
all the buildings shown here – only the
mansions survived. The distant church
tower belonged to St Matthew's Highland
Memorial Church on Bath Street, which
was gutted by fire in 1952.

OG.1955.121.[318]

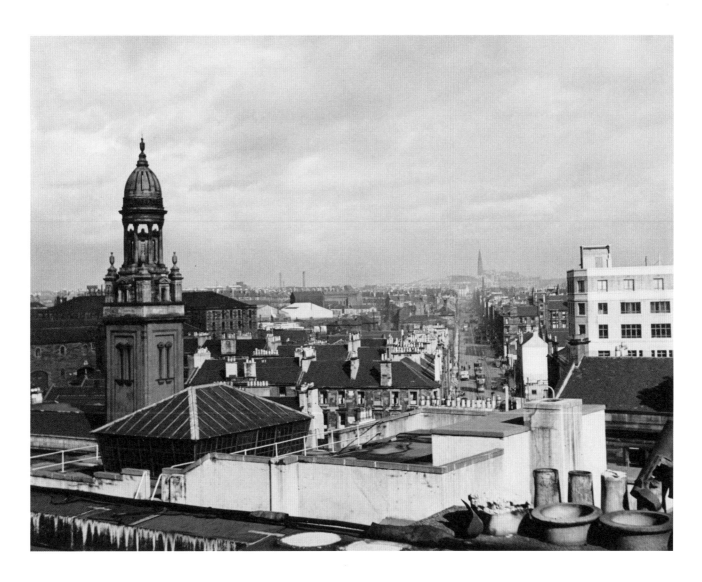

Parliamentary Road
Hugh Patrick
Scottish Ramblers Association

Hugh Patrick took this photograph from the roof of Glasgow Corporation Transport Head Office, 46 Bath Street. Looking northeast, this image shows the junction of Buchanan Street, Sauchiehall Street and Parliamentary Road. The church tower on the left belonged to St John's Methodist Church and its site is now occupied by Glasgow Royal Concert Hall. In the distance is the tower of Blochairn Church in Royston.

OG.1955.121.[339]

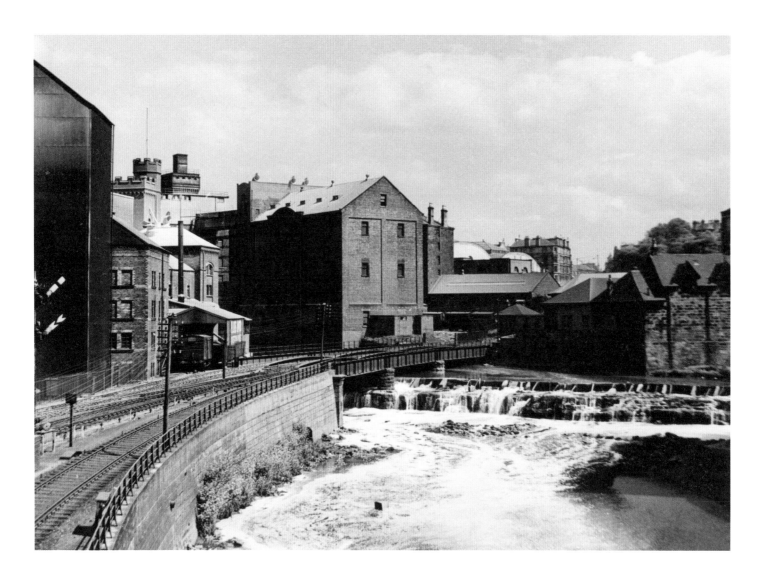

■ **A Corner of Partick from the Partick Bridge**
James Logan
Partick Camera Club

River Kelvin looking north from Partick Bridge. On the left you can see the top of the bakery which still occupies the same site today. Kelvin Hall can just be seen on the right hand side.

OG.1955.121.[306]

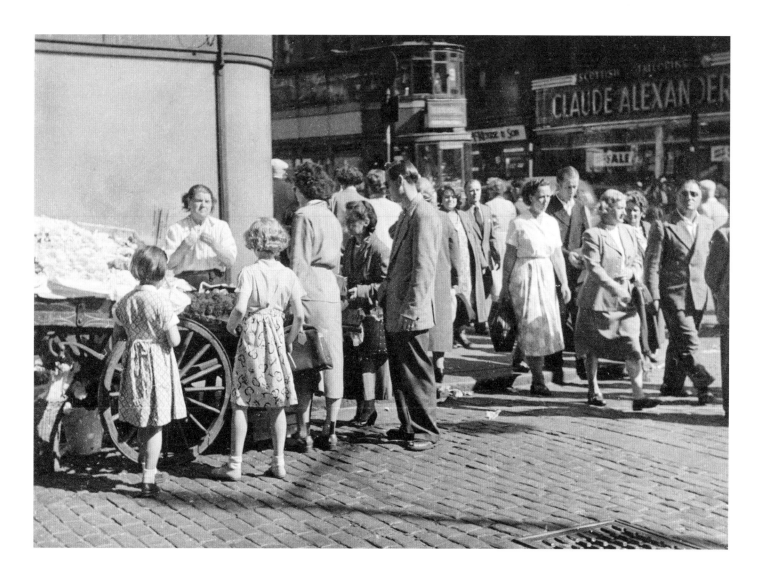

Saturday Evening – Corner of Virginia Street and Argyle Street
Robert Saunders
Dennistoun Camera Club

A view of Virginia Street looking south towards Argyle Street. Annie Leonard helps out at the stall of Mary Anne Brown, stall licence holder since the 1920s. The fruit stall is still run by the Brown family today, but moved to the bottom of Virginia Street when Argyle Street was pedestrianized in the 1970s.

OG.1955.121.[51]

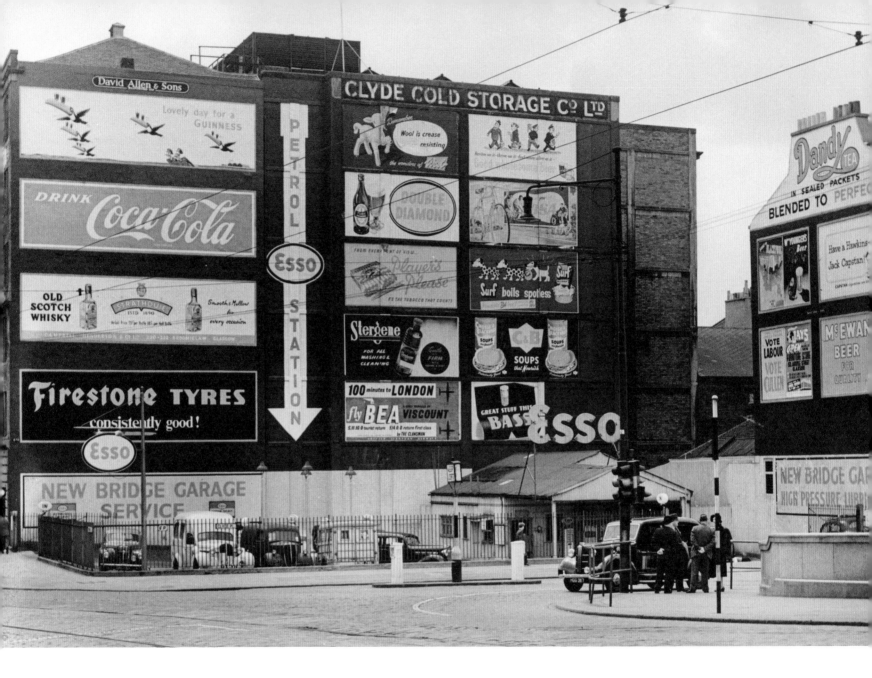

Bill Posters – Clyde Place
DC Sutherland
Queen's Park Camera Club

A view from George V Bridge looking south to Clyde Place at Commerce Street. The adverts on the gable ends provide an insight into products available in the 1950s. Some of these, such as Surf, Stergene and McEwan's lager are still available today, others such as Dandy Tea are long gone. The rules of advertising have changed. Tobacco adverts are now banned and you are no longer able to promote beer by saying, 'Revive on it – thrive on it – feel more alive on it – Good wholesome beer'. The small scale of the New Bridge Garage petrol station also shows that private cars were not as numerous in 1955 as they are today.

OG.1955.121.[130]

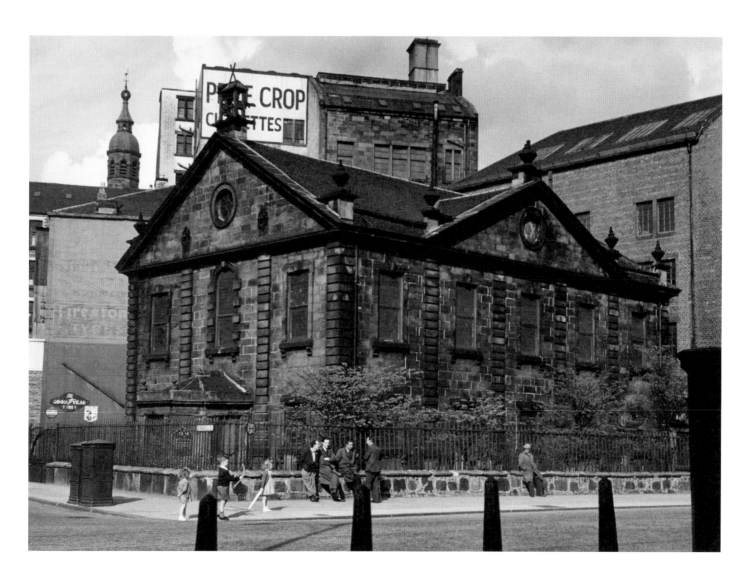

St Andrew's by the Green
DH Johnston
Drysdale's Photo Art Club

St Andrew's by the Green was the oldest Episcopal church in Scotland. It was built between 1750 and 1752, and used as a place of worship until 1975. After a period of disuse and neglect, the church was converted into offices for a housing association in 1988. It is now the headquarters of the Glasgow Association for Mental Health. The adjacent buildings were used as warehouses, and the area has now been restored to residential use. The tower to the rear belongs to St Andrew's Parish Church.

OG.1955.121.[334]

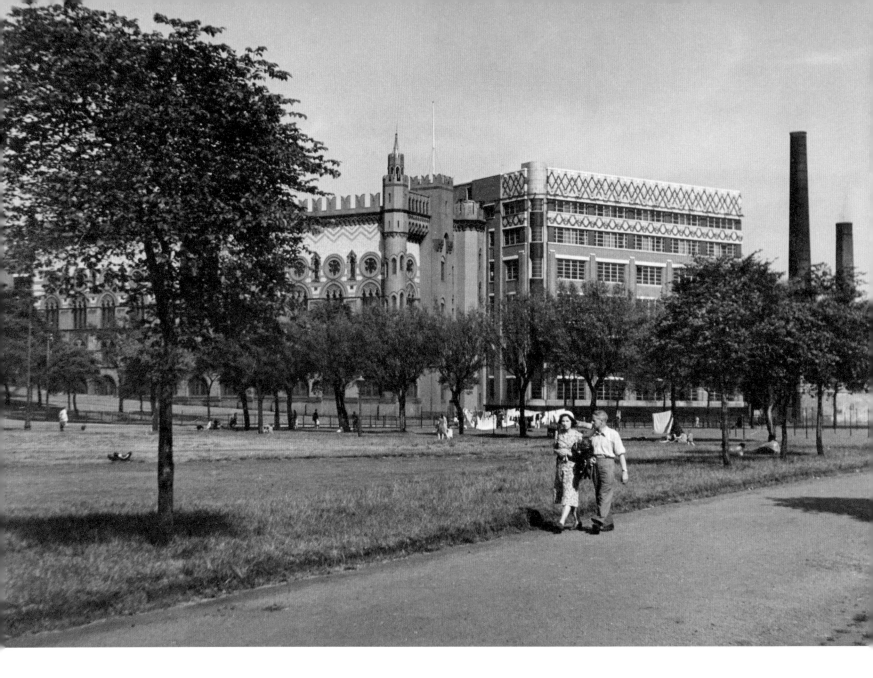

■ Glasgow Green – Templeton's Carpet Factory
Hugh Patrick
Scottish Ramblers Association

This ornate building was built as Templeton's Carpet Factory, where premium carpeting was made and exported around the world. After a period as a business centre it was converted into housing. The chimney to the right belonged to Greenhead Baths and Wash-house – washing can be seen drying on the clothes lines to the centre of the photograph. The washhouse has been demolished, but the washing poles remain and are still available for use today.

OG.1955.121.[338]

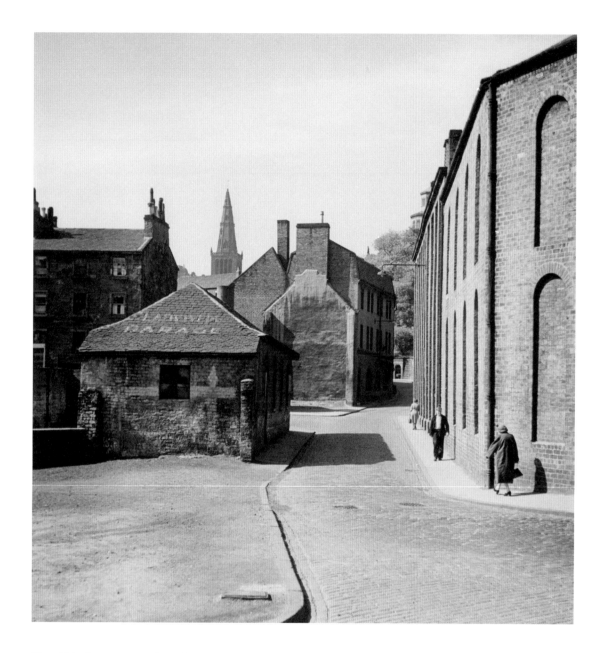

■ **Old Glasgow – Ladywell Street**
A MacDonald
Dennistoun Camera Club

Ladywell Street looking north at the corners of Wright Street, Parkhouse Lane and the Drygate. This area is now part of the Tennent Caledonian Brewery. To the left is the tower of Glasgow Cathedral, and on the right is the Necropolis. In the distance is the Ladywell, which closed as a water source in 1833 for fear of contamination from the nearby cemetery. Ladywell Garage was previously Glasgow's oldest 'ragged school' – a school for teaching the poor.

OG.1955.121.[379]

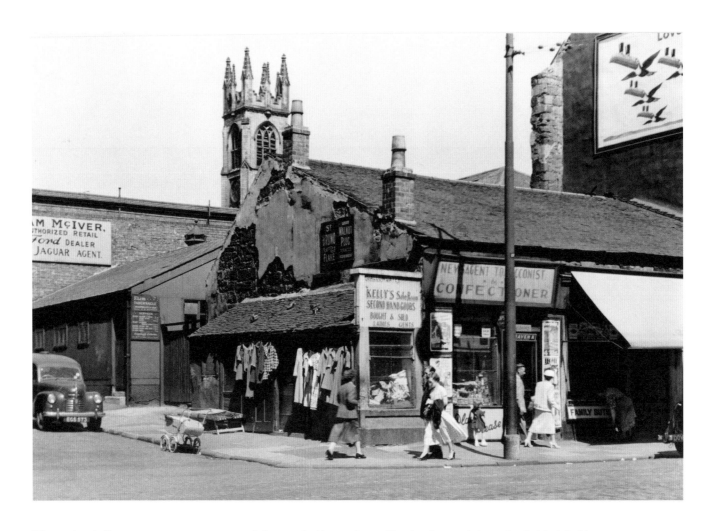

In the Gallowgate
A Graham
Queen's Park Camera Club

Gallowgate looking north east. The church tower belonged to St John's Parish Church, which stood at the head of McFarlane Street. It was built in 1819 and demolished in 1962. The small shop on the corner is trading in second-hand goods, and was on the corner at the foot of East Campbell Street.

OG.1955.121.[138]

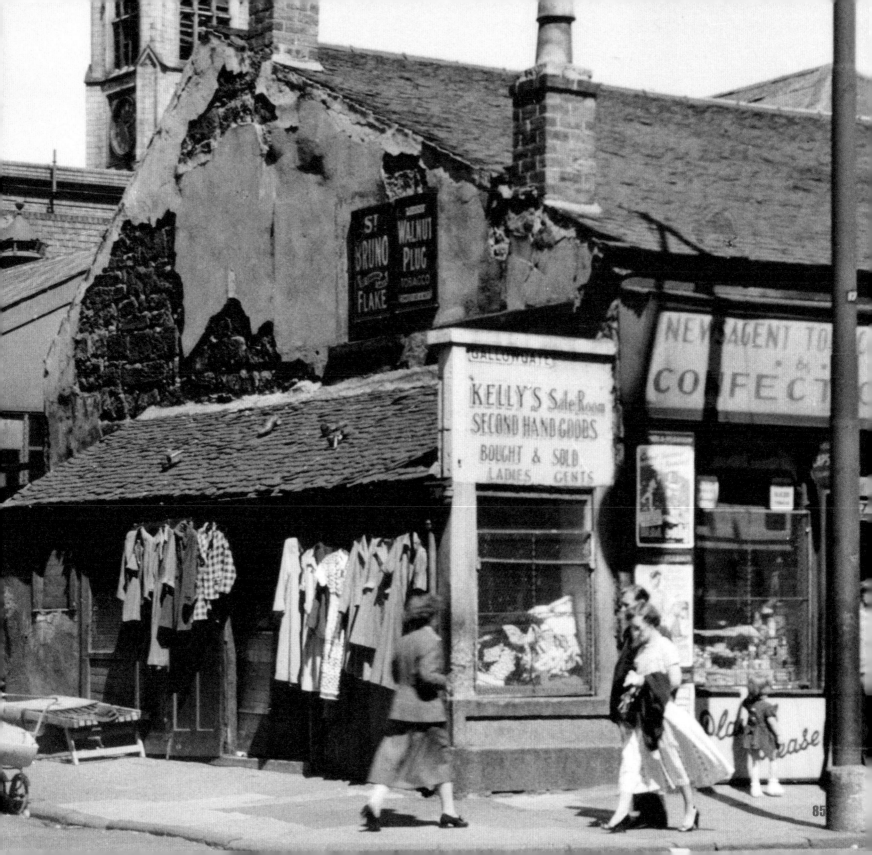

ST BRUNO and FLAKE

WALNUT PLUG TOBACCO

GALLOWGATE

KELLY'S Sale Room
SECOND HAND GOODS
BOUGHT & SOLD
LADIES GENTS

NEWSAGENT TO

CONFECT

85

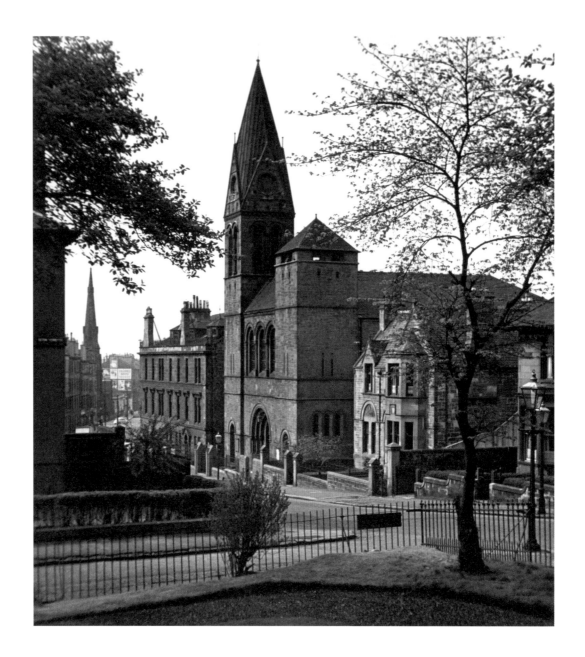

■ **Blackfriars Parish Church**
Louis L Strachan
Dennistoun Camera Club

Westercraigs looking south towards Bellgrove Street. Blackfriars Parish Church was built in 1876–1877, and replaced an older building on the High Street. Its bell tolled every six hours, but was stopped when the Eastern District, or Duke Street, Hospital opened in 1904 – perhaps because it would have disturbed the patients. It closed for worship in 1983, and was converted into flats in the late 1980s. The tenement to the left forms one part of the junction on Duke Street at Bellgrove Street, the junction itself being named King's Cross.

OG.1955.121.[141]

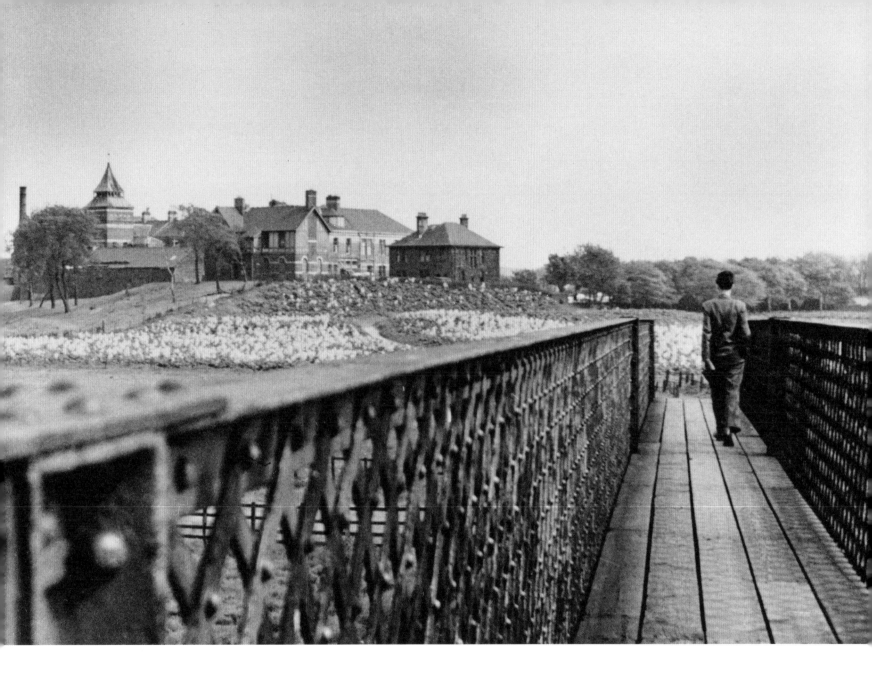

■ **Mossbank Industrial School from the Quarter Mile Bridge, Millerston**
RFS McGregor
Dennistoun Camera Club

The Quarter Mile Bridge served as access to Robroyston Station, which opened in 1896 and closed in 1956. Mossbank Industrial School opened in the late 19th century to provide poor relief – it housed neglected and destitute children. Boys were taught a trade and girls were taught domestic duties. It finally closed in 1970.

OG.1955.121.[82]

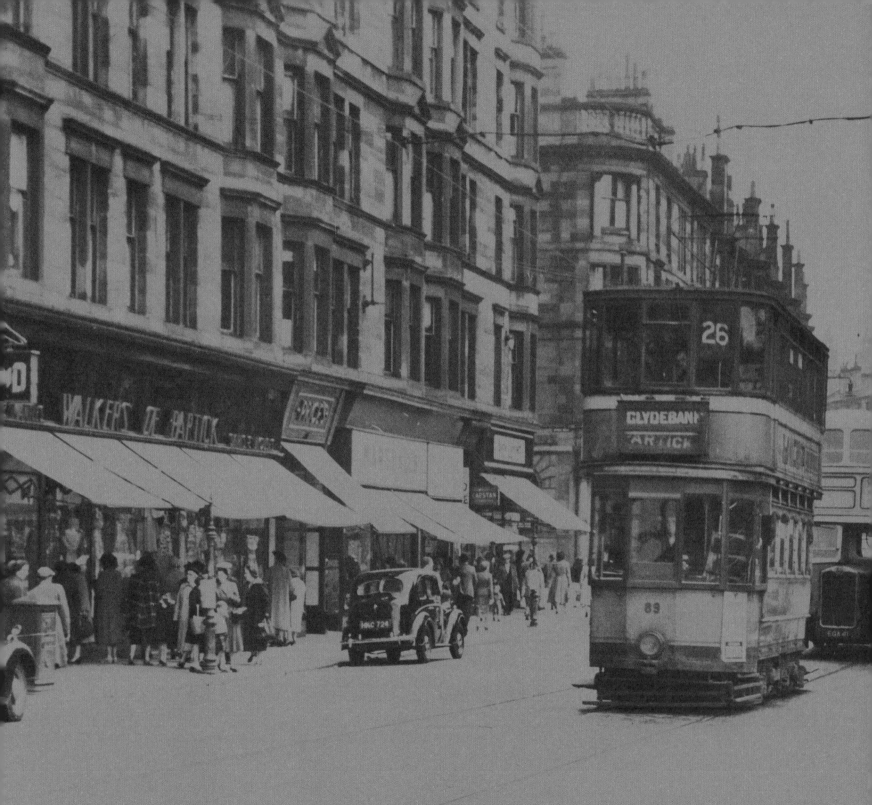

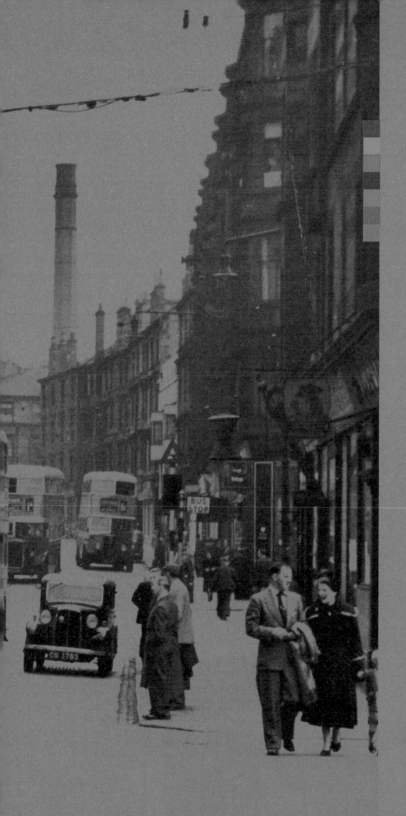

STREET SCENES

❝ I remember women pushing prams full of bundles for washing, going along to the steamie. I also remember the noise of the shipyards, the clanging and bustle. There were plenty shops in those days where you could buy practically anything you needed. Memories – memories of long ago. ❞

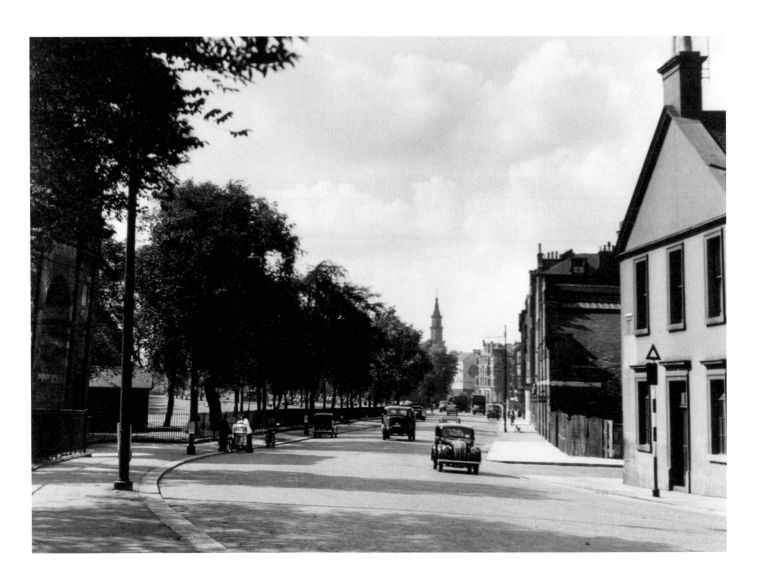

■ **Greendyke Street**
Alexander Graham
Queen's Park Camera Club

Greendyke Street looking west towards Saltmarket. Glasgow Green is on the left of the image, and the house in the right foreground was latterly part of the Camp Coffee works. The south entrance to Charlotte Street is also on the right, although the extension to Our Lady and St Francis School, which remains on the site, had yet to be built. The Merchants' Steeple, visible to the centre of the image, was built in 1665 and had been spared demolition when the Merchants' House was demolished in 1818.

OG.1955.121.[145]

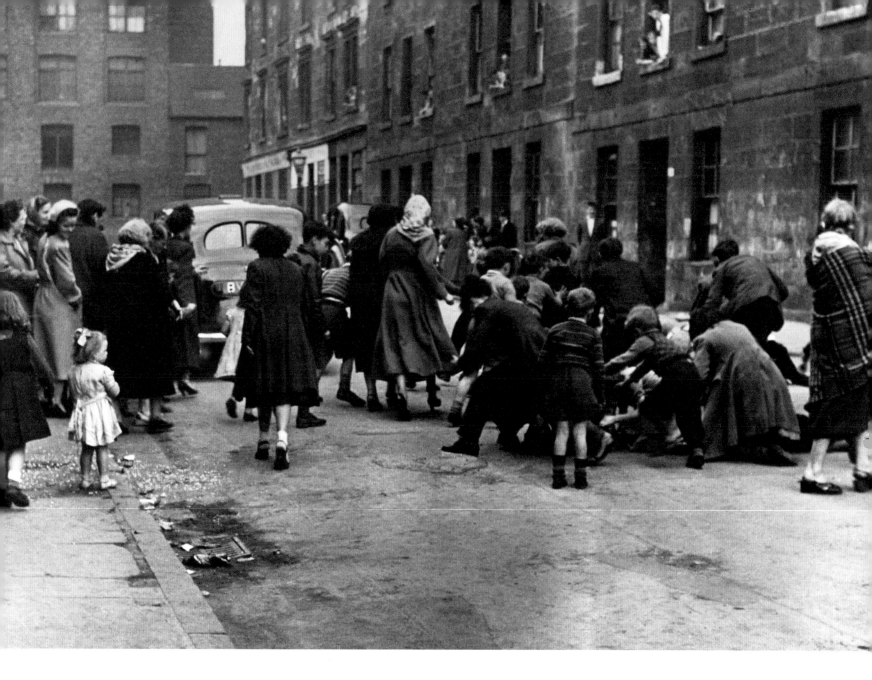

■ **The Scramble, Gemmel Street**
F Remich
Dennistoun Camera Club

A 'scramble' in Gemmel Street, Bridgeton. Scrambles were, and in some places still are, a tradition at weddings in many parts of Scotland. Neighbours turned out to see the bridal party leave the street on its way to the church. Coins were thrown from the wedding car – usually by the father of the bride – as it drove off, and children scrambled to pick up as much money as they could.

OG.1955.121.[67]

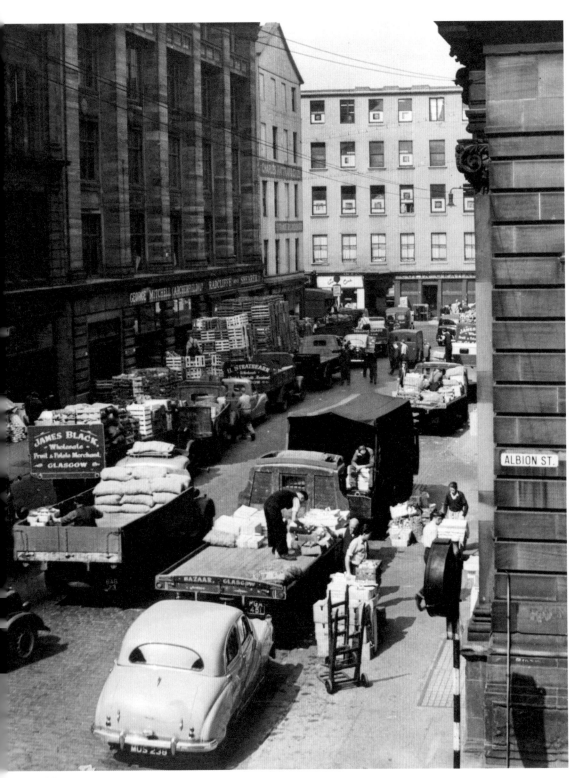

Glasgow Fruit Market
W Harrison
Kemsley House Camera Club

Bell Street looking towards Candleriggs.
The building on the corner at the right is
Candleriggs Market, where goods were
bought and despatched to fruit shops
across the city. The fruit market moved from
Candleriggs to its current site in Blochairn
in the 1960s. This building is now at the
centre of the redeveloped Merchant City,
where it houses restaurants and bars.

OG.1955.121.[14]

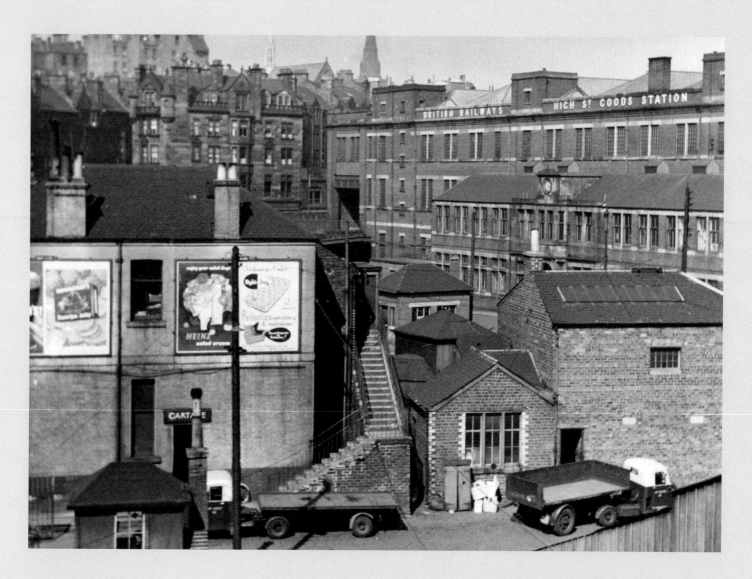

View of High Street
AM Allison
Dennistoun Camera Club

This view of High Street is looking north to Duke Street, taken from the offices of College Goods Yard. In the distance to the left is the end of Rottenrow, with the Cathedral tower to the centre of the image. The High Street Goods Station, built in the early 1900s, was demolished in 1984 and the site is currently used as a car park. The site of College Goods Yard is currently being redeveloped into College Lands, so named after the site's link with the original University of Glasgow. The tenements to the left of the image are still there today.

OG.1955.121.[106.a]

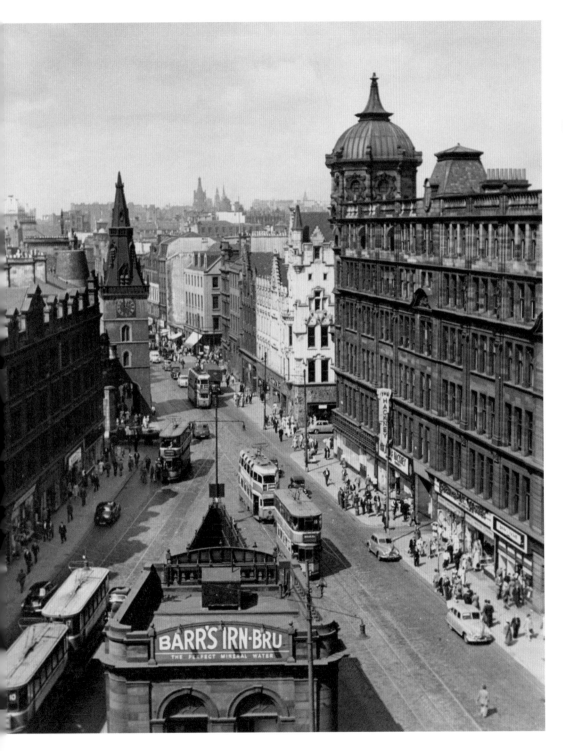

■ **Trongate**
Louis L Strachan
Dennistoun Camera Club

Trongate at Glasgow Cross, looking west from the
Mercat Cross Building. In the foreground is Glasgow
Cross Station – in 1923 the building shown here
replaced the original 1895 station building. The station
was closed in 1964, and demolished in 1977. The rest
of the view has changed very little in the years since this
photograph was taken, although cars and buses have
now replaced the trams seen here.

OG.1955.121.[218]

facing page
■ **Argyle Street – Saturday Afternoon**
Louis L Strachan
Dennistoun Camera Club

Argyle Street looking east from the north side of
St Enoch Square, taken at 4.30pm on a Saturday
afternoon in May. Burton Menswear on the left
remained in the building from its erection in the 1930s
until recently. All of the buildings in this block have
undergone substantial redevelopment, although most
retain their original façade.

OG.1955.121.[288]

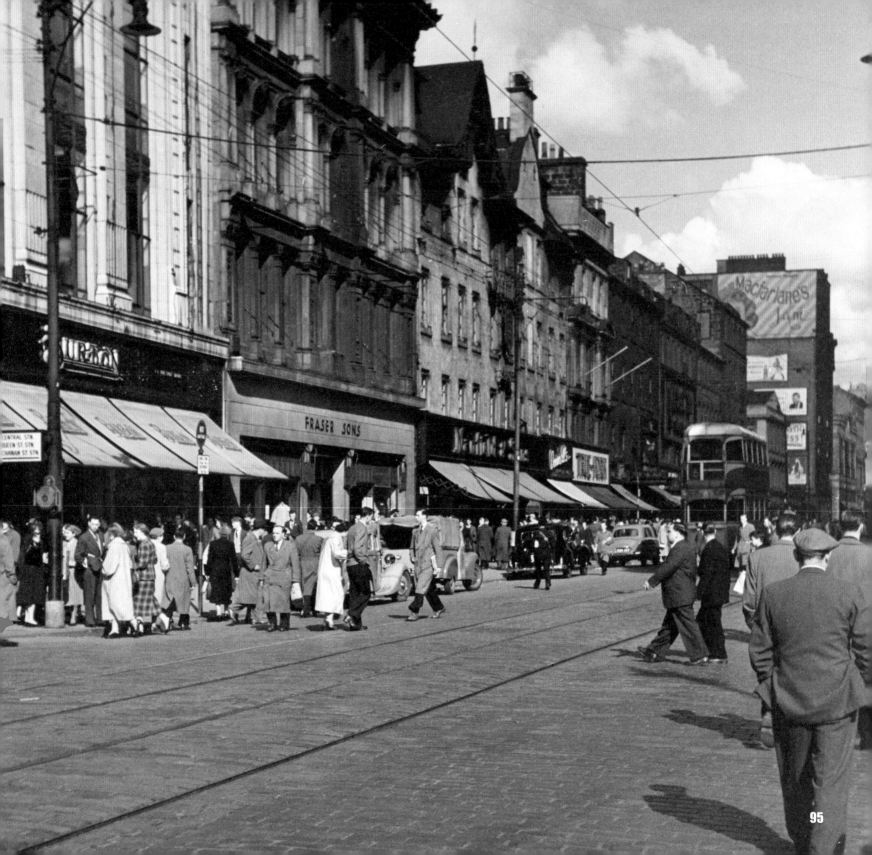

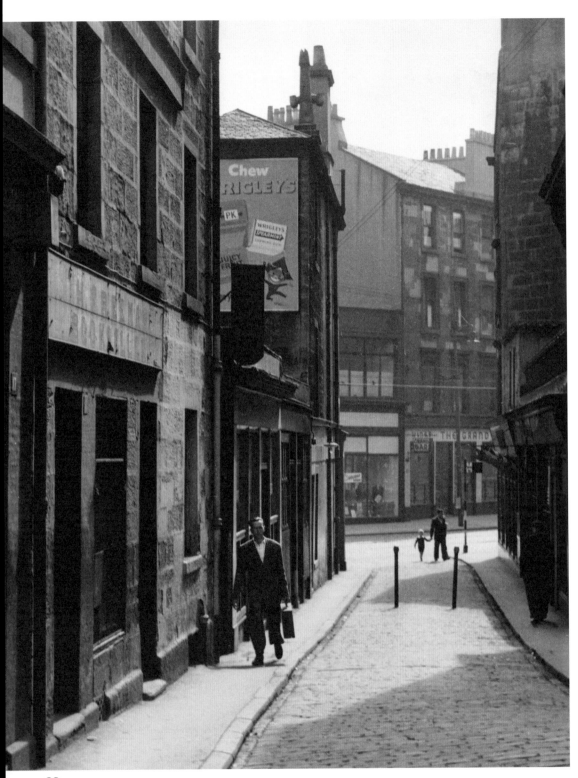

In the Cowcaddens
RB Simpson
Knightswood Camera Club

Cowcaddens Street is at the end of this narrow lane. Part of Dallas's Ltd department store is visible on the opposite side of the street next to the Grand Bar, which took its name from the nearby Grand Theatre. This area of Cowcaddens was demolished during redevelopment in 1973.

OG.1955.121.[37]

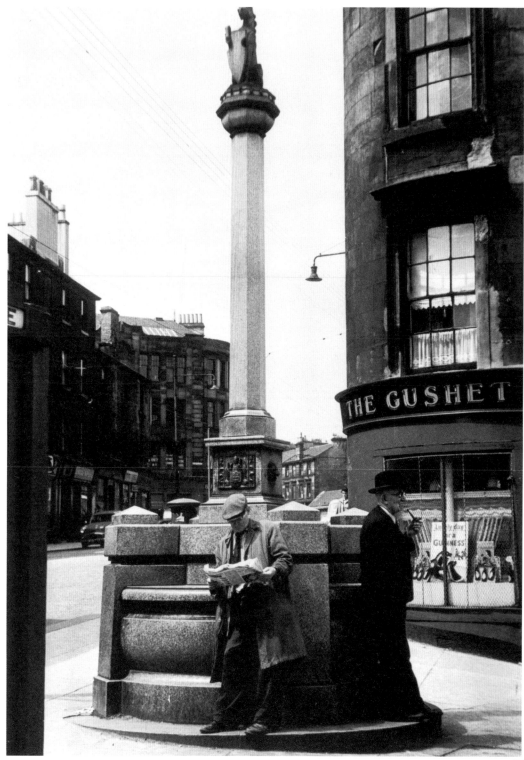

■ **Annan Fountain, Cowcaddens**
James L Henderson
Scottish Ramblers Association

This fountain is situated on the gushet – junction
– between Cowcaddens and Port Dundas Road.
It bears the inscription, 'Presented to the City of
Glasgow in 1915'. The area was progressively
demolished from the late 1950s, and was
completely redeveloped by 1973. The site of this
photograph is approximately where the high-rise
flats and M8 motorway are today.

OG.1955.121.[315]

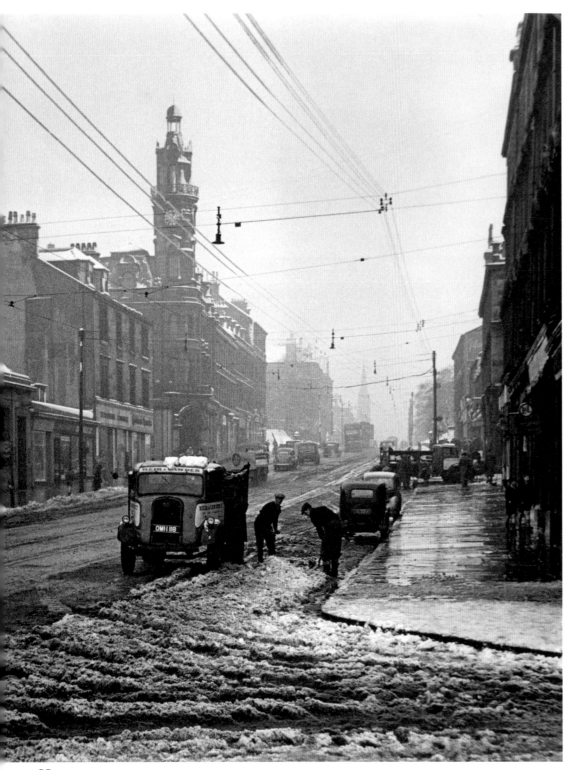

■ **Great Western Road – Winter Scene**
John S Logan
Scottish Ramblers Association

This view of Great Western Road is looking west
from the foot of Colebrook Street. The wintry
scene would have been more common in the
1950s, as our climate has become milder since
then. The snow on this occasion was driven in on
a northerly wind – you can see this by the snow
lying on only one side of the buildings.

OG.1955.121.[236]

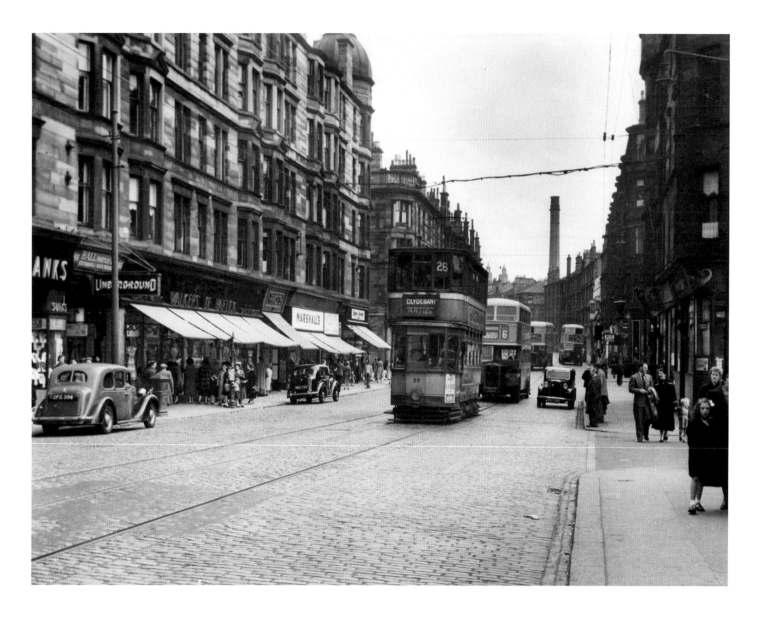

■ **View of Partick Cross I**
Alf Daniel
Partick Camera Club

Dumbarton Road at Partick Cross, looking east towards the foot of Byres Road. On the left can be seen the entrance to Partick Cross Subway Station, which was renamed Kelvinhall in 1977. The good weather is hinted at with the drawn awnings of the shops on the north side protecting the goods in the window from the sun, and the fact that some people are carrying their coats.

OG.1955.121.[227.a]

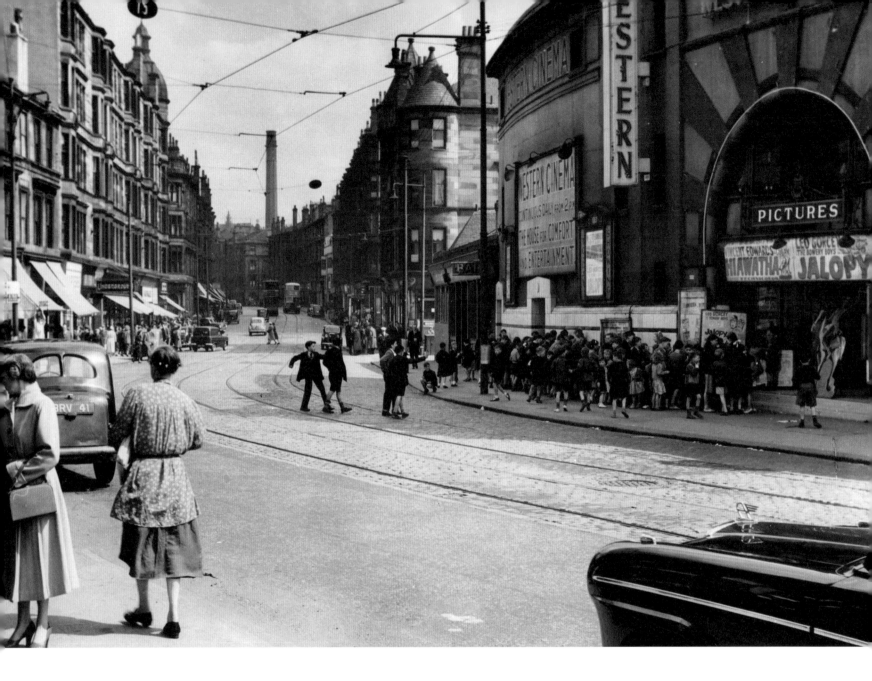

■ **View of Partick Cross II**
Alf Daniel
Partick Camera Club

Dumbarton Road looking east towards Partick Cross. The children are queuing outside the Western Cinema to see the Saturday matinee, which that day was *Jalopy* and *Hiawatha*. The chimney in the distance belongs to the pumping station at the bridge over the River Kelvin, which is still in use today.

OG.1955.121.[227.b]

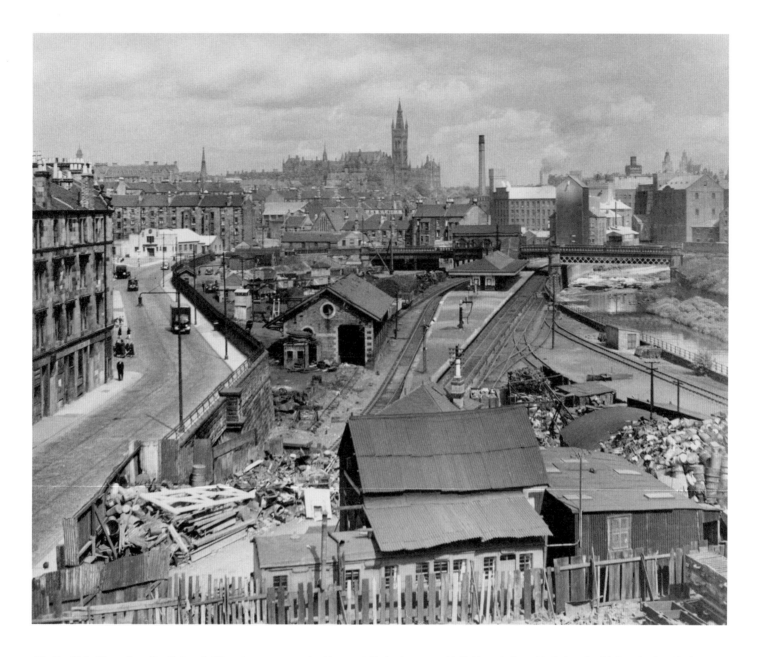

■ **Partick, Showing Castlebank Street**
Andrew Gibb
Partick Camera Club

Looking east. To the foreground is Robinson's Scrap Yard, then Partick East Station. To the right is the River Kelvin and on the left is Castlebank Street. In the distance is the tower of the University of Glasgow, and to the right of the photograph are the Partick Flour Mills.

OG.1955.121.[189]

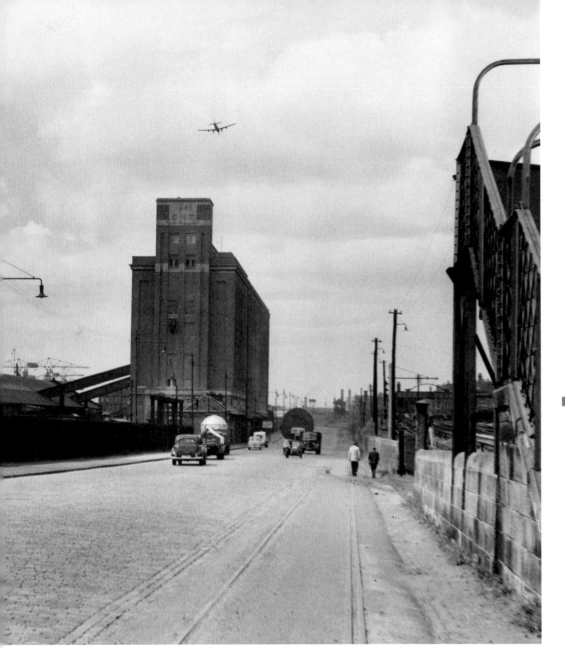

Castlebank Street
Alf Daniel
Partick Camera Club

Castlebank Street looking into South Street, Partick. The large building on the left is the Clyde Navigation Trust Granary, where grain shipped in from overseas was stored before being sent to bakeries across the country. It is clearly marked CNT on the end. The granary building, which was used for storing grain, was demolished at the start of the 21st century. The photographer was keen to show that in 1955 this street was used mostly by industrial vehicles. In the sky is an airliner heading in to land at Renfrew Airport.

OG.1955.121.[307]

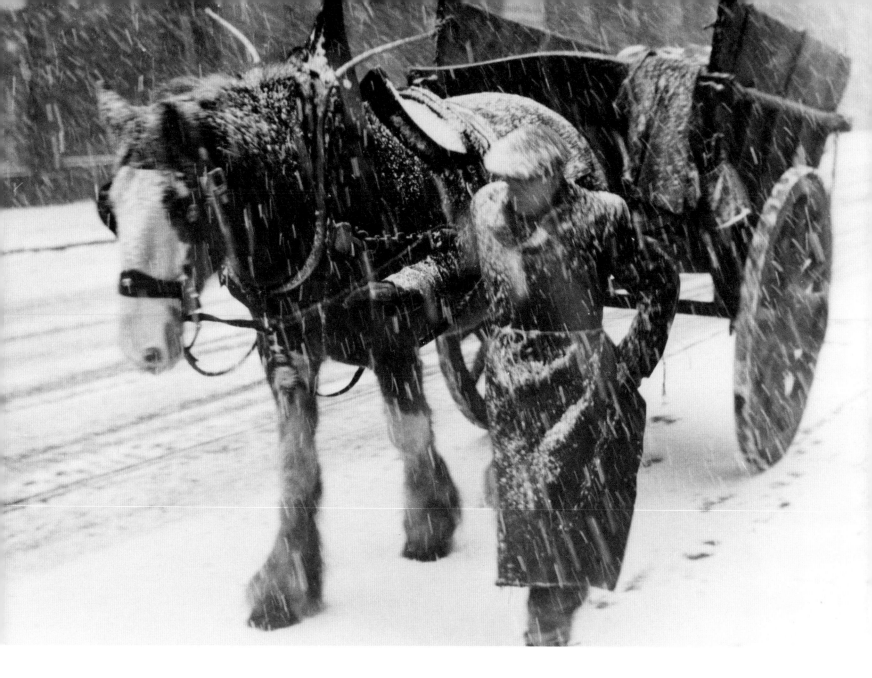

A Dying Mode of Transport
Alf Daniel
Partick Camera Club

The title of this winter scene originally referred to the fact that by 1955 the number of horses and horse-driven vehicles was in decline, as motorized vehicles took their place transporting goods across the city.

OG.1955.121.[286]

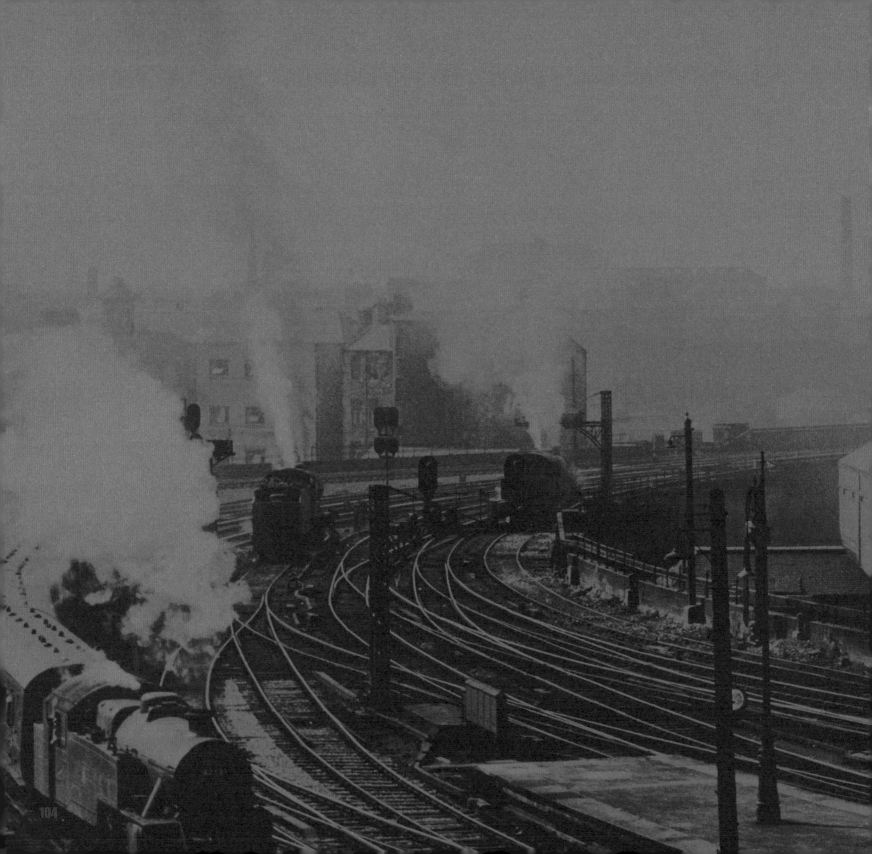

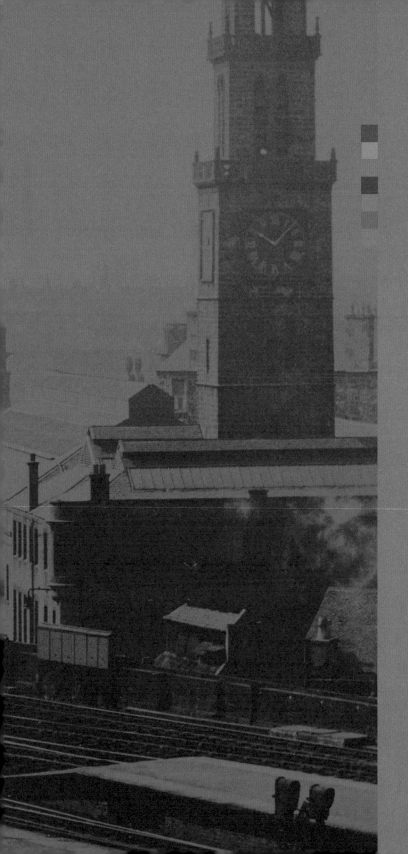

ON THE MOVE

" I lived in Springburn and the picture of the locomotive passing Rockvilla School brings back memories. A "loco" leaving Springburn was the equivalent of a ship launch to us. "

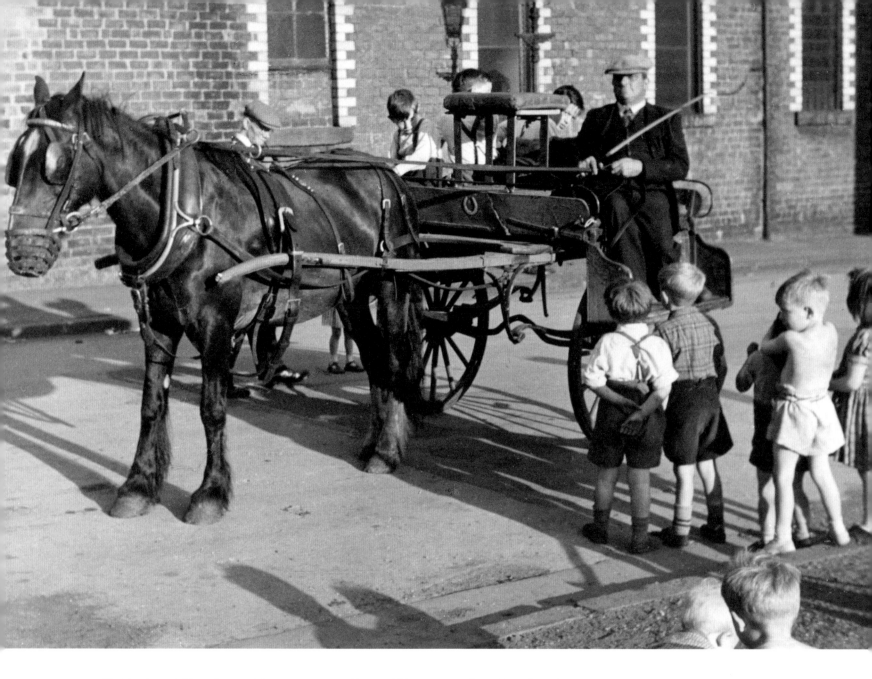

The Pony Ride – Gemmel Street
F Remich
Dennistoun Camera Club

Bridgeton children queue up for a ride on this Irish jaunting cart, described by the photographer as, 'Probably the only one of its kind in Glasgow, on which the children ride round the block – price one penny'. It also shows the city's Irish connection, as Bridgeton was an area where many Irish workers settled.

OG.1955.121.[68]

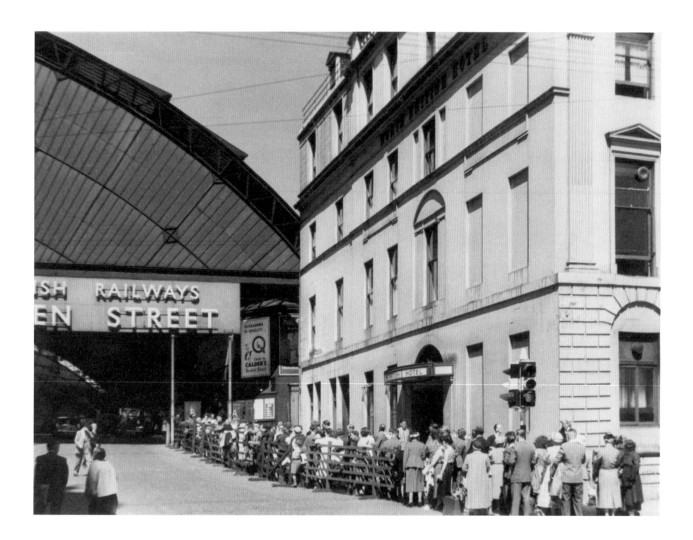

■ **Queen Street Station, Glasgow Fair Saturday**
Thomas Robertson
Partick Camera Club

Early afternoon on Glasgow Fair Saturday, and the city empties as its citizens take their annual Fair Fortnight holiday. Factories and offices traditionally closed in July for two weeks. From Queen Street Station these holidaymakers might be on their way to the north, east or west of the country. Opened in 1842, Queen Street is Glasgow's oldest surviving railway station.

OG.1955.121.[88]

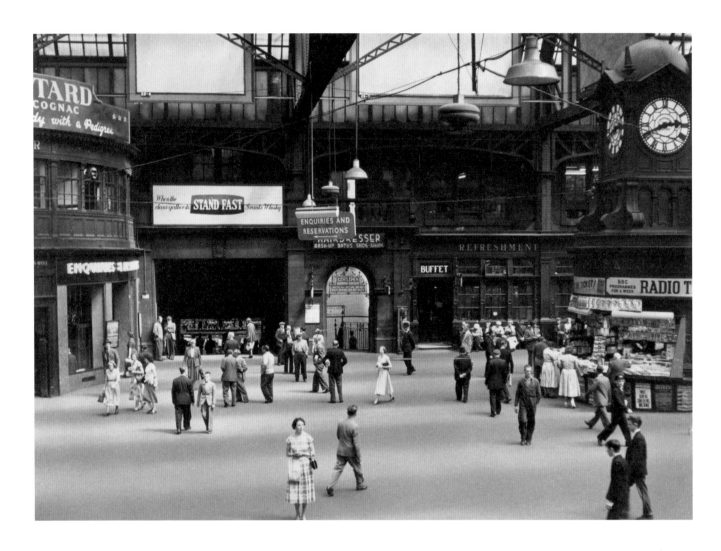

British Rail Central Station
S Taylor-Duncan
Partick Camera Club

At Central Station the photographer noted that the 'Fair crowds have already left', on their annual Fair Fortnight holiday. At this time holidaymakers would still make their way 'doon the watter' to towns on the Ayrshire coast, although coach trips to Europe were also becoming popular in the 1950s. Central Station opened in 1879.

OG.1955.121.[168]

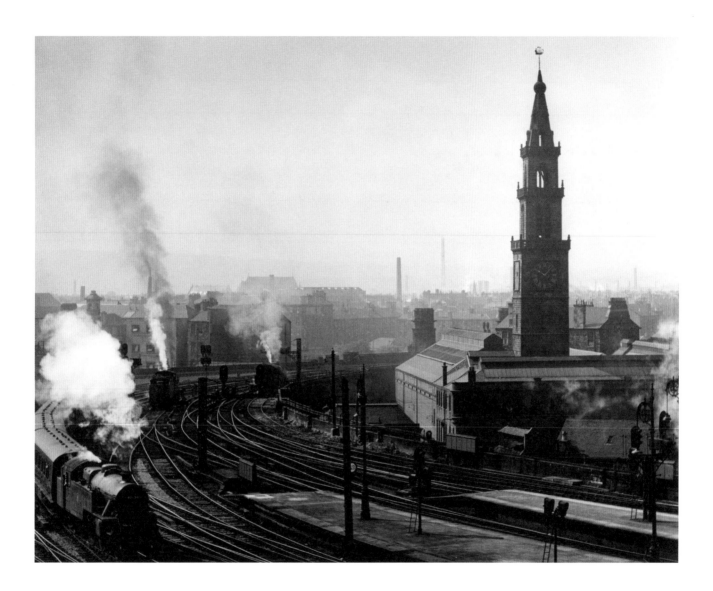

■ **St Enoch Station with Fish Market**
Paul M Cassidy
Queen's Park Camera Club

Taken from a signal box or bridge on a June morning, this photograph shows the station platforms and railway lines that run southeast across Stockwell Street and the Bridgegate to the City Union Railway Bridge over the River Clyde. The Fish Market, built in 1873, is on the right, surrounding the Merchants' Steeple. In 1977 the market moved to a new site.

OG.1955.121.[220]

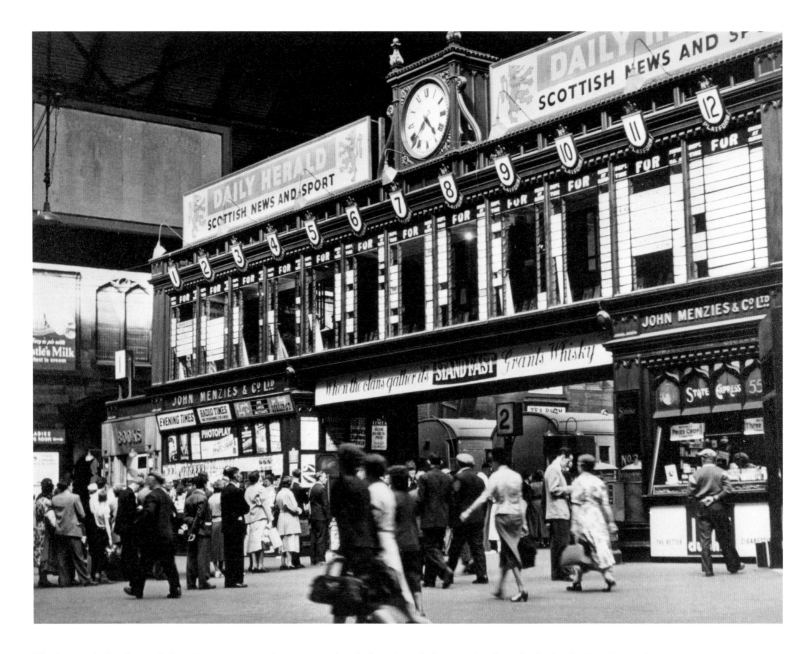

■ **St Enoch Station – Going Away**
S Taylor-Duncan
Partick Camera Club

Passengers wait to find out their platform number from the destination board. From St Enoch Station trains served local stations, and stations in Ayrshire, Stranraer, Dumfries, and England via the Midlands. In 1953 an average of 24,650 passengers used the station every day. The station closed in 1966, and was demolished 11 years later. The St Enoch Shopping Centre now stands on the site.

OG.1955.121.[368]

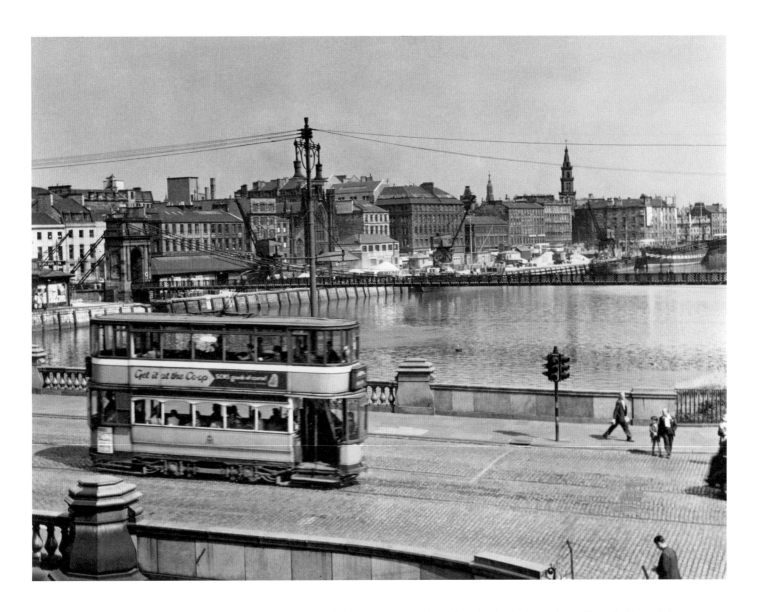

Jamaica Street Bridge
S Taylor-Duncan
Partick Camera Club

This view, taken from Central Station Railway Bridge, looks northeast along the River Clyde. In the foreground is Jamaica Street Bridge, also known as Glasgow Bridge or Broomielaw Bridge. This third version of the bridge opened in 1899. Further along is the South Portland Street Suspension Bridge. The *Carrick*, the Royal Naval Volunteer Reserve Club, lies moored on the north bank. Still recognizable today is the Merchants' Steeple.

OG.1955.121.[373]

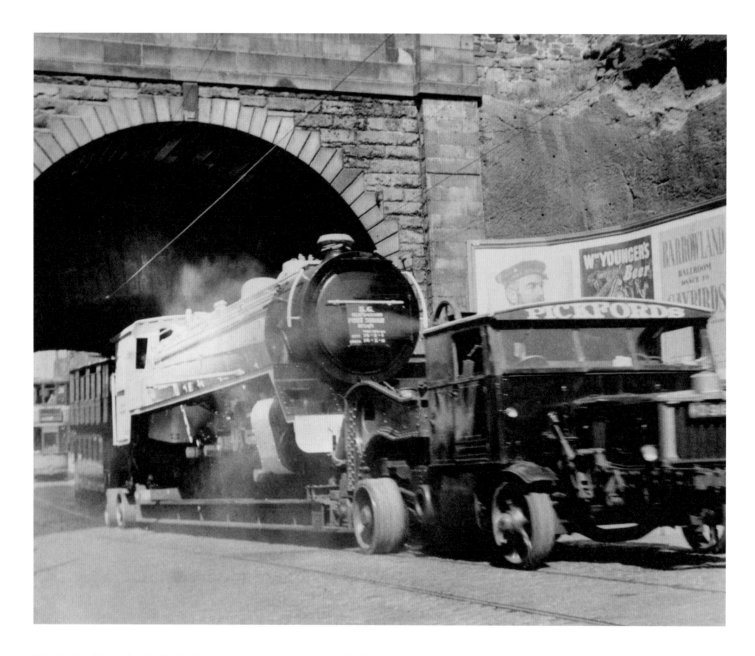

■ **Engine from the Hyde Park**
Locomotive Works
R Miller
Partick Camera Club

In 1955 you could still see heavy locomotives being transported along the streets to the docks to be sent overseas. In Springburn, a 'loco' leaving was the equivalent of a ship launch. Taken by truck from the Hyde Park Locomotive Works in Springburn, this engine is passing under the Forth and Clyde Canal at Rockvilla Bridge. In the background trams wait in line to proceed, and the tramlines and cables can clearly be seen.

OG.1955.121.[242]

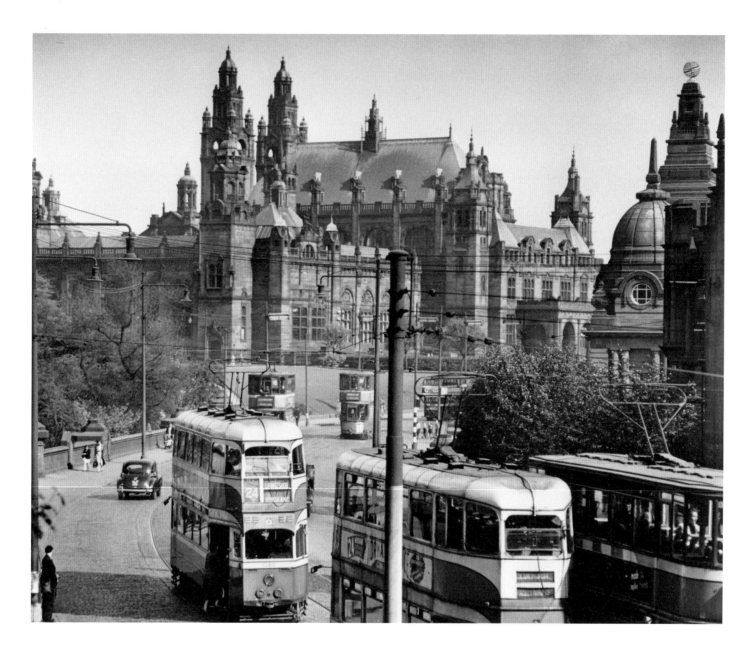

■ **The Art Galleries from Partick Bridge**
JM McCorquodale
West of Scotland Club

Looking east along Argyle Street from Partick Bridge, the major change since 1955 has been the traffic. Glasgow trams are long gone, and there are many more cars on the road. Kelvingrove Art Gallery and Museum remains, as does the Kelvin Hall on the right. Before the SECC – the Scottish Exhibition and Conference Centre – was built, Kelvin Hall was Glasgow's main exhibition centre, holding the city's annual circus and carnival.

OG.1955.121.[336]

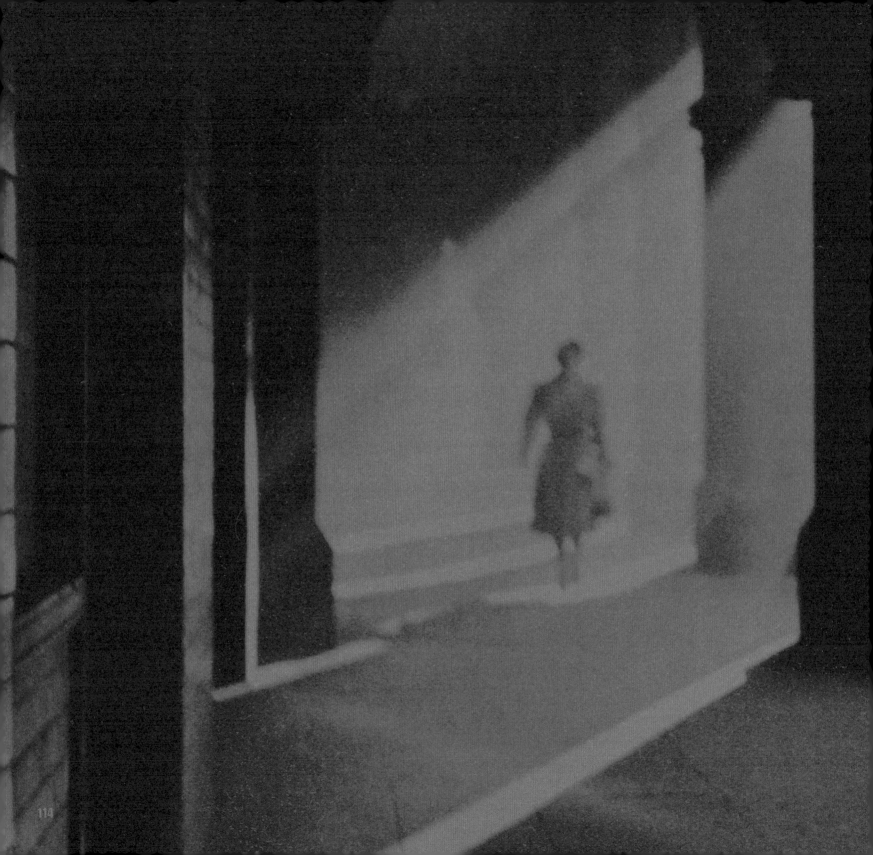

PICTURE IT

" I remember going to school with a woollen scarf across your chest, criss-crossed tied with a safety-pin, to keep you warm, and your sand shoes getting whitened for Sunday School and wearing your best clothes only when you went to Church. You would get 3d for the plate, 1 penny to spend and you would spend the 3 pence and put the penny in the plate. "

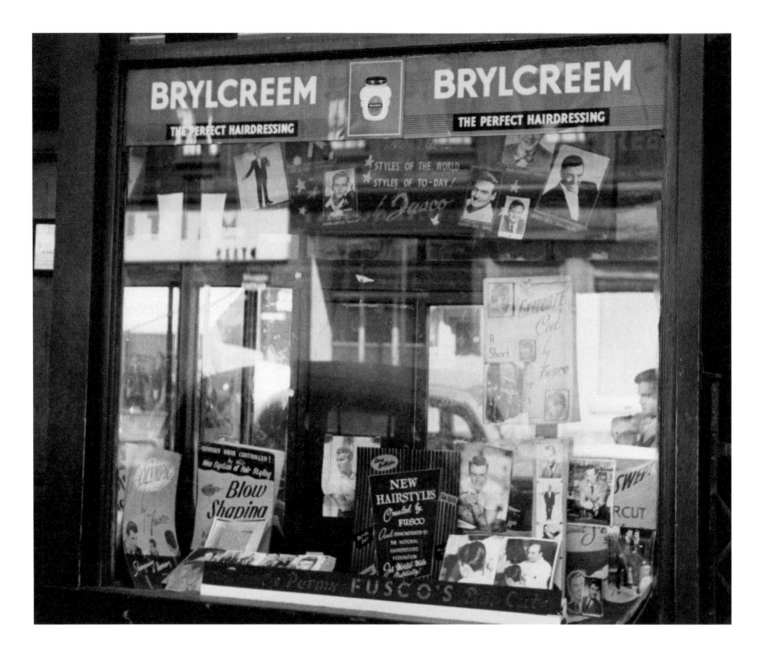

Film Star Haircuts, Fusco's Barber's Shop, Cambridge Street
Thomas Robertson
Partick Camera Club

On the back of this photograph it says, 'Film star haircuts! A Cambridge Street hairdresser who caters for the tastes of the young bloods of Glasgow in hair styling. Imitations of American film stars tonsorial style varies in price according to the star'. Fusco's was a favourite haunt of Glasgow's Teddy Boys. This photograph was taken on Sunday 24 July 1955.

OG.1955.121.[98]

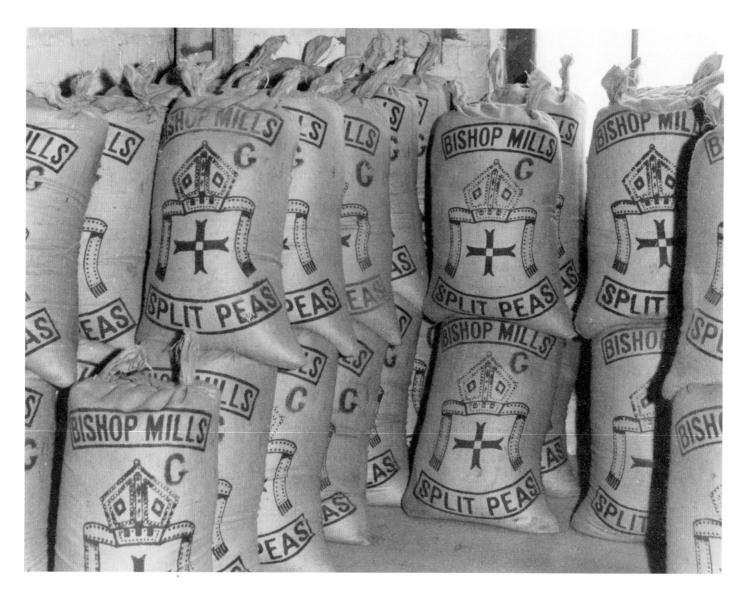

■ **Glasgow's Mills – Bishop's Mill Products**
Hugh McNicholl
Partick Camera Club

These sacks of split peas from Glasgow's oldest mill lie neatly stored. Bishop's Mill, also known as Partick Mill or the Archbishop's Baronial Mill, is believed to have been built before 1136. It was one of four major mills on the River Kelvin. The building has now been converted into flats.

OG.1955.121.[305.b]

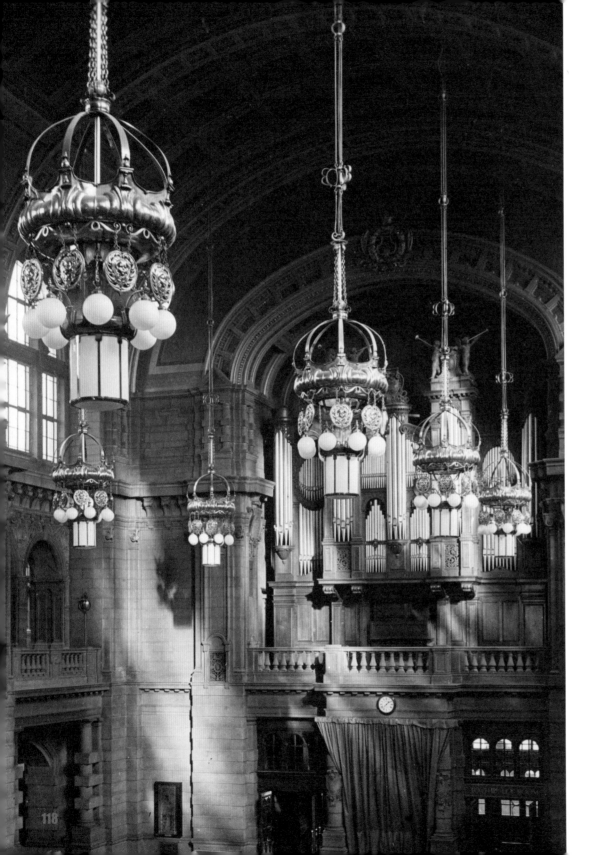

■ **Chandeliers – Art Galleries**
JM McCorquodale
West of Scotland Club

A photograph of the luminaires in the centre hall of Kelvingrove Art Gallery and Museum. They were part of the building's original fittings in 1901, when it opened as the Palace of Arts at the Glasgow International Exhibition, and are still part of the building today.

OG.1955.121.[308]

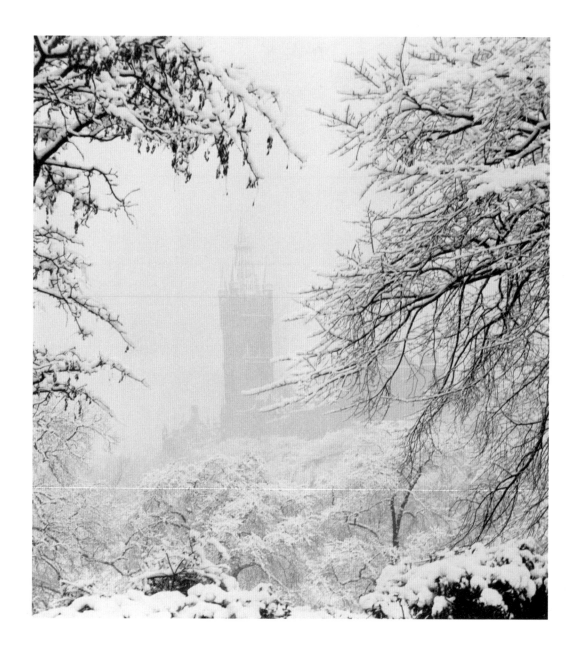

■ **Glasgow University**
Alf Daniel
Partick Camera Club

The University of Glasgow seen from Kelvingrove Park. Winters have become milder in Glasgow since 1955, and such heavy snowfall is now a much rarer occurrence.

OG.1955.121.[323]

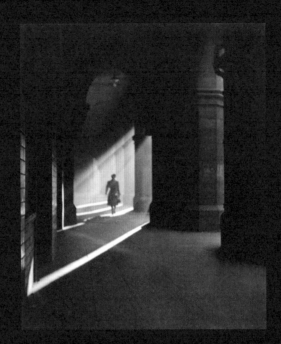

The Arches, Howard Street
D Carmichael
Glasgow South Co-operative Club

This woman stands as if suspended in time in this atmospheric photograph of the arches in Howard Street, on the south side of St Enoch Station. Is she walking towards the camera or away from it? The station closed in 1966, and was demolished 11 years later. It is now the site of the St Enoch Centre, one of Glasgow's main shopping centres.

OG.1955.121.[284]